YOU CAN PAINT

MARIE BLAKE trained as a painter at Kingston-upon-
Thames School of Art and later qualified as a teacher of art
at Central College, London University. She has taught art
at primary and secondary level and also has experience of
teaching part-time and leisure painters. She exhibits her
own paintings and is a regular contributor to *Leisure
Painter* magazine. This is her first book.

YOU CAN PAINT

PASTELS

A step-by-step guide for
ABSOLUTE BEGINNERS

MARIE BLAKE

First published in 2000 by
HarperCollins*Publishers*
77-85 Fulham Palace Road
Hammersmith
London W6 8JB

Collins is a registered trademark of
HarperCollins*Publishers* Limited

The HarperCollins website address is
www.**fire**and**water**.com

06 05 04 03 02 01 00
9 8 7 6 5 4 3 2 1

**A catalogue record of this book is available from the
British Library**

Editorial Director: Cathy Gosling
Editor: Diana Vowles
Designer: Penny Dawes
Photography: Nigel Cheffers-Heard

ISBN 0 00 413403 6

Colour reproduction by Colourscan, Singapore
Printed and bound by Rotolito Lombarda SpA, Italy

CONTENTS

INTRODUCTION

It is not uncommon for people to feel that they would love to paint but lack sufficient knowledge and time. There is the question of which to choose from a bewildering range of brushes, pigments and papers, as well as the numerous accessories that seem to be required.

There is no need for such apprehensions with pastels; they do not depend on tools and solvents, being simply paints in dry stick form, ready for immediate use. As soon as you open a box of pastels your fingers will itch to handle the various colours and make tentative scribbles to see how they respond – and at that moment you have already started to paint. Perhaps it is their resemblance to the boxes of crayons we are given in childhood, when our creative impulses are not inhibited by our fear of failure, that makes pastels seem so accessible to use.

The making of marks is a basic human compulsion, and if it is exercised regularly your hands will learn to respond automatically, giving you the freedom to paint creatively. Right from your first experiments in pastel you will find yourself making lines that are as fine as pencil marks and broad masses similar to brushstrokes. These discoveries allow you to develop your drawing and painting skills simultaneously, an advantage that pastels are unique in offering.

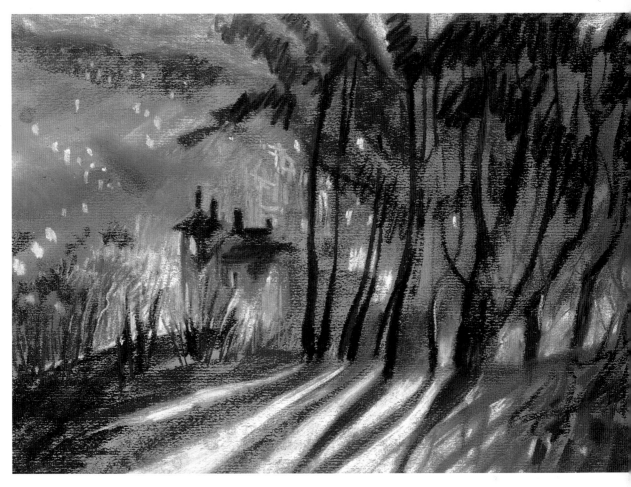

Through the Garden at Night
20 x 29 cm (8 x 11½ in)

Being able to paint successfully depends upon being able to draw, and drawing in its turn depends upon being able to see objects in a different manner to the practical everyday method. This 'reflex drawing' produces a natural way of working that is both relaxing and fun. It is also the basis of this book.

On the same principle of working freely, do not be concerned about other people's reactions to your early paintings. If you aim to please others, you will be depriving yourself of valuable learning experience. There is tactile as well as visual satisfaction to be had from painting with pastels and even the most basic exercise will express the pleasure you feel when you paint in pastels just for yourself.

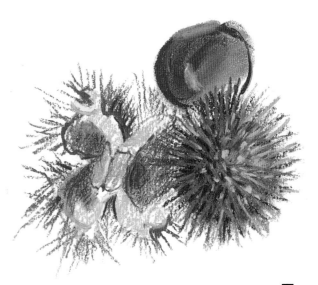

HOW TO USE THIS BOOK

This book is designed to teach you by presenting images for you to work with and then develop further yourself. The early pages are devoted to basic mark-making that will teach you to how to handle pastels. Once you are familiar with their use, you can tackle the exercises in reflex drawing and painting; these will teach you how to allow the pastel in your fingers to follow the rhythm of the scene while you use your eyes to study what is before you rather than anxiously watching what is appearing on the paper.

Of course, to paint successfully you must understand how to use colour. On pages 22–9 you will learn about colour relationships so

Beach Huts out of Season
26 x 21 cm
(10 ¼ x 8 ¼ in)

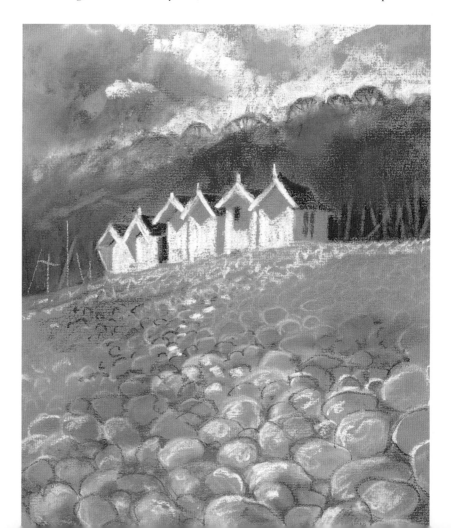

that you will be able to make the right choices of which pastels to buy and how to mix them to achieve the effects you want.

Choosing interesting subjects and handling them to absorb their tactile quality is an important part of painting. Once you have progressed through the basic exercises, this book offers you the chance to practise the portrayal of subjects from nature such as trees, flowers and the seashore, as well as the people and animals that give life to a landscape.

The book is intended to give you an enjoyable start in the use of pastel, a fulfilling and exciting medium. It does not cover subjects such as linear perspective, which require more practice. Instead, it shows you how to make pictures from straightforward viewpoints so that right from the start you can produce work that will inspire you to explore pastels further rather than feeling discouraged about your abilities. It opens a new world that offers fun as well as creative fulfilment – and further adventure to be had as your skills develop.

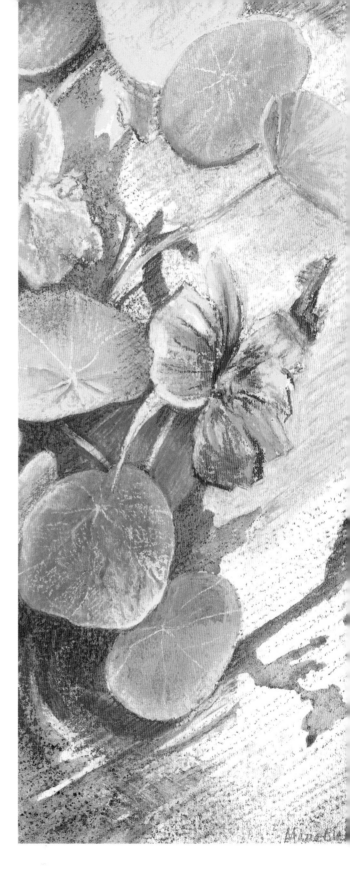

Nasturtiums and Shadows
30 x 12.5 cm
(11 ¾ x 5 in)

BASIC MATERIALS

As a beginner, it is easy to equip yourself for painting with pastels without a great deal of outlay or research. In fact, just six pastels and a sketchbook will suffice to allow you the chance to discover whether you wish to explore this exciting medium further.

The pastels There is a vast range of pastels on sale. Daley-Rowney colours have been used throughout this book, but with experience you can explore other manufacturers' pastels and mix brands. Pastels are labelled with a tint number, the higher numbers indicating

stronger colours. So, for example, Burnt Umber 8 is a very dark brown while Burnt Umber 1 is a pale biscuit colour.

Round pastels are soft and produce the most painterly effect, while square pastels are firmer and good for linear detail. Pastel pencils are the cleanest to hold.

To begin with, buy six basic colours: two reds, two blues and two yellows, choosing a warm and a cool shade in each. You can either buy them loose or, if you are happy to spend more money, as part of a set. Once you have completed the section on colour mixing (pages 22–9) you can make your own personal selection of the colours that will suit your style.

Preliminary studies and initial drawings can be done in charcoal, an inexpensive medium.

Pastel papers These have a textured surface to hold the pastel particles. They are available in a large range of colours, whether as loose sheets or as pads of assorted colour. White papers can be used for studies, but mid-toned coloured papers are easiest for painting. A useful size is 305 × 229mm (12 × 9 in).

A spiral-bound sketchbook of 229 × 153mm (9 × 6 in) is suitable for outdoor work. Sketchbooks are supplied with white, cream or

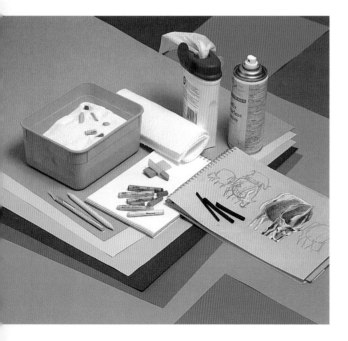

All the basic equipment you need to start painting in pastels.

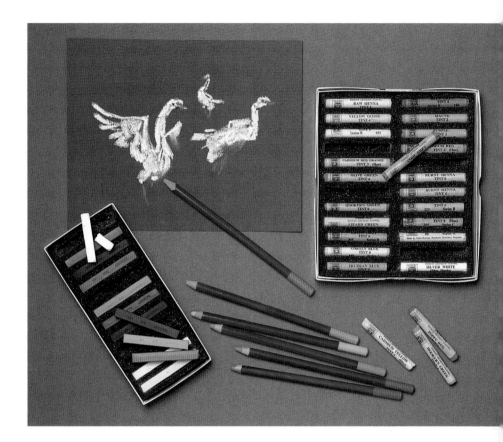

*A selection of round
and square pastels
and pastel pencils.*

coloured papers. The pages are interleaved
to prevent the pastel from smudging the
adjoining page.

Optional extras Torchons made of
compacted paper are useful for blending and
drawing the pastel into areas that are too small
for your finger. Clean and renew the point by
sharpening it with a craft knife. Kitchen paper
(referred to as 'tissue') can be used for general
blending purposes.

Pastel paintings are fragile but can be 'fixed'
by covering them with smooth paper and
placing them under a heavy board.

Alternatively, use aerosol fixative, following the
manufacturer's instructions. Do not apply it
heavily or it will darken the colours, and use it
only in a well-ventilated room.

An eraser is used for lifting colour to leave
highlights, not for correcting mistakes. Buy a
kneadable eraser or one made of good-quality
plastic, not a rubber one. To lift narrow lines,
simply cut the eraser into thin strips.

To clean your fingers, use moist wipes or a
damp sponge. Pastels can be cleaned by
shaking them gently in a container of ground
rice, available from grocery shops and health
food stores.

MAKING MARKS

Before you can learn to paint successfully, you first need to find pleasure in just making marks. Here are a few suggestions on which to base your inventiveness. You will need two pastels, fixative, a torchon, an eraser, kitchen paper ('tissue'), and white pastel paper (see pages 8–11).

Make a light stroke (left); break the pastel and use its sharp edge for a thin line (centre); drag a wide band with its full length (right).

Repeat, but using increased pressure.

Working horizontally, graduate each stroke from heavy to light.

Apply diagonal stripes (known as 'close-hatching' or 'infill').

Repeat and blend by rubbing gently with tissue.

Repeat and blend with a finger.

Make diagonal spaced blue lines ('hatching').

'Crosshatch' in a counter direction with yellow.

Finger blend the yellow into the blue.

Drag a band of blue next to a band of yellow. Finger blend them together.

Drag a blue horizontal band, then cross it with a vertical yellow band. Notice the colour blend.

Repeat, but spray with fixative before applying yellow. Notice the colour separation.

Heavily infill in blue then finger blend gently to obscure the individual strokes.

Transfer the colour left on your finger to make a fingerprint texture.

Alternatively, rub the colour into the paper to give a diffused texture.

Make blunt stipple marks with a short length of blue pastel then overlay them with yellow.

Make sharp stipple marks in blue, then in yellow.

Gently flick feathering strokes in blue, followed by yellow.

From marks to shapes

As you continue to experiment with making marks you will find that some spontaneously begin to take on recognizable shapes, in the same way that idle doodles invariably turn into faces and forms rather than remaining meaningless scribbles.

a) Use colour on your finger, then lift and shape it; b) make a heavy line, then pull horizontal lines from it with the point of a torchon; c) Make blue and yellow lines and pull colour from each.

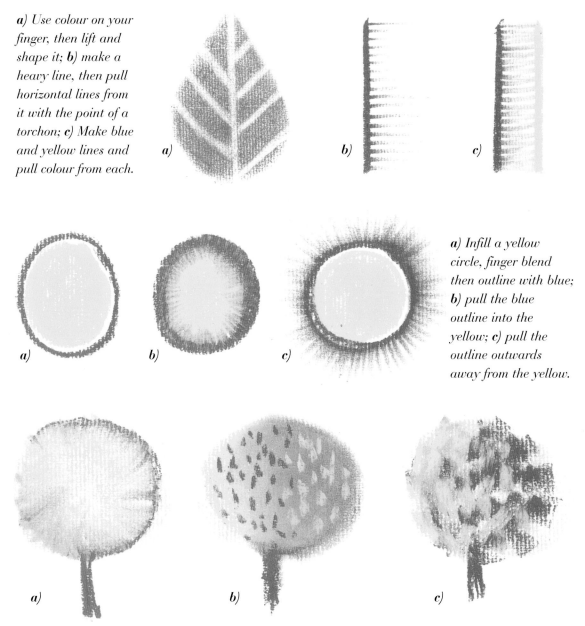

a) Infill a yellow circle, finger blend then outline with blue; b) pull the blue outline into the yellow; c) pull the outline outwards away from the yellow.

Using the techniques you have learnt so far, make your first basic pictures by a) pulling an outline and infilling with yellow; b) blending one colour into another and stippling over the top; c) making blunt stipple marks with a short length of pastel.

Toned papers

A coloured paper is the traditional surface for pastels. It saves you from having to cover the whole surface and is therefore cleaner and more economical to use. More importantly, it helps you to achieve a balance of light and dark in a picture by establishing a mid tone.

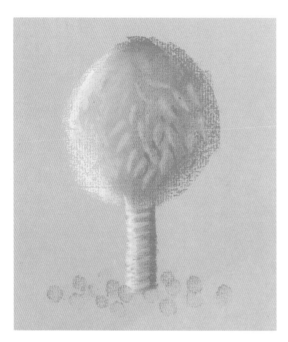

Left: *Here the background is light in tone yet dark enough for the light left-hand side of the tree to be more visible than it would have appeared on white paper.*

Below: *The same tree on a mid-toned paper which lowers the contrast between the background and the light and dark sides of the tree.*

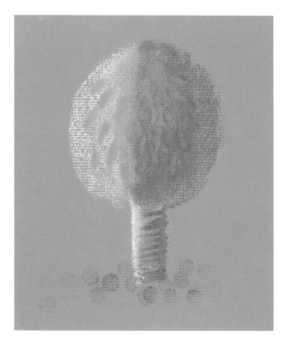

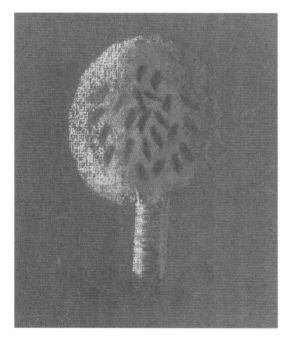

Left: *Here the paper is too dark in tone, with the result that the right-hand side of the tree has merged into the background.*

Drawing with your eyes shut

You cannot paint without drawing, and this is especially true of pastels. These preliminary exercises are relaxing and fun but are also significant in developing your drawing skills. Close your eyes for each exercise, then check the result before progressing to the next.

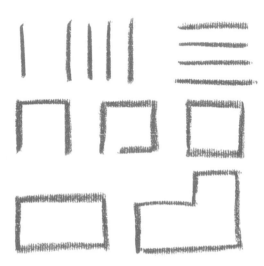

*1 **Top:** a line; four equally spaced vertical parallel lines; four horizontal parallel lines. **Centre:** Three sides of a square; a square drawn in a continuous line, the last edge falling short; a perfect square. **Bottom:** a rectangle; a square-angled irregular shape.*

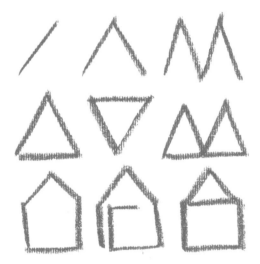

*2 **Top:** a diagonal line; two sides of a triangle; the letter M. **Centre:** a triangle; an inverted triangle; a double triangle. **Bottom:** an open triangle on an open square; two house shapes.*

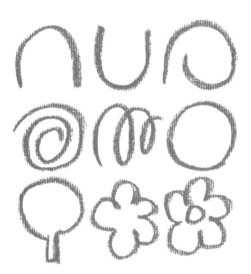

*3 **Top:** a downward curve; an upward curve; a scroll. **Centre:** a curl; a spring; a circle. **Bottom:** a tree shape; a flower shape; a flower with a centre.*

Painting with your eyes shut

When you have had plenty of practice with the drawing exercises on the previous page you can move on to painting with a short length of pastel. As before, the exercises are based on squares, triangles and circles.

1 **Top:** *With the pastel held horizontally as shown, pull three strokes; pull one long vertical stroke; push, with a final move to the right.* **Centre:** *With the pastel held vertically, make three left to right strokes; one long left to right stroke; and one left to right stroke with a final upward movement.* **Bottom:** *Mixed vertical and horizontal strokes.*

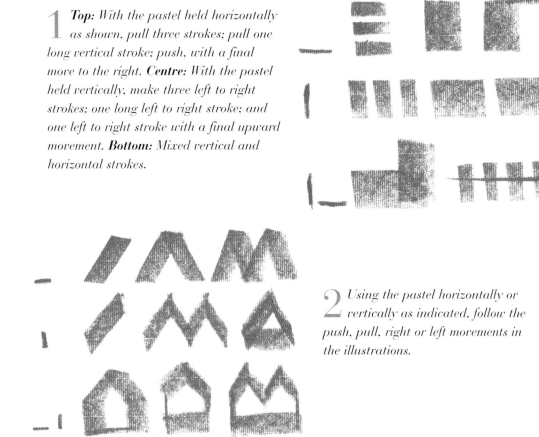

2 *Using the pastel horizontally or vertically as indicated, follow the push, pull, right or left movements in the illustrations.*

3 **Top:** *with the pastel held horizontally, push and pull in one smooth movement; pull and push; push, pull and push.* **Centre:** *with the pastel held vertically, push and pull; pull and push; push, pull and finish with a push.* **Bottom:** *with the pastel vertical, push, pull and complete the circle; repeat horizontally; repeat with the pastel held at an oblique angle.*

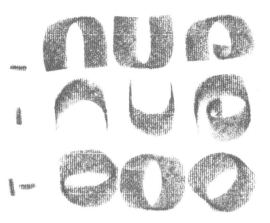

Basic images

The square and circular shapes from the previous exercises are used in this basic drawing, which is also to be done with your eyes closed. Practise it several times then invent a design of your own, including some triangular shapes.

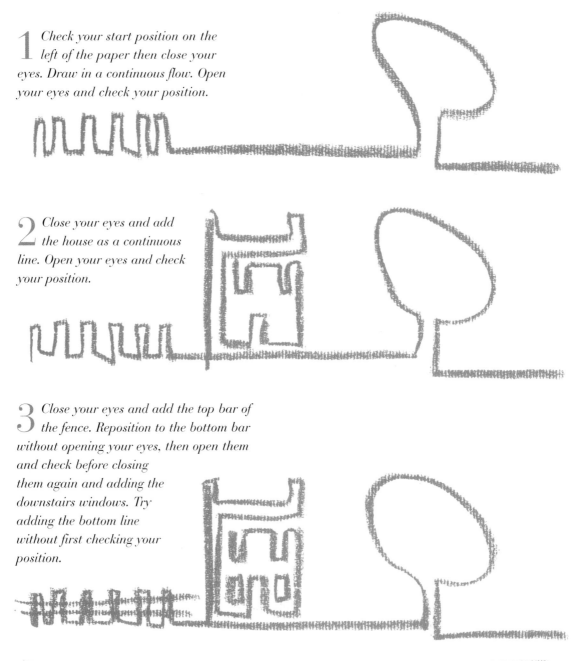

1 *Check your start position on the left of the paper then close your eyes. Draw in a continuous flow. Open your eyes and check your position.*

2 *Close your eyes and add the house as a continuous line. Open your eyes and check your position.*

3 *Close your eyes and add the top bar of the fence. Reposition to the bottom bar without opening your eyes, then open them and check before closing them again and adding the downstairs windows. Try adding the bottom line without first checking your position.*

1 *Using a short length of pastel, make two sideways sweeps for the roof and four short sideways marks for the windows. Turn the pastel and pull it towards you for a door. Practise before proceeding to the next step.*

2 *Make a tree in a curling movement, followed by a straight pull. Relocate for a baseline beneath the picture. Practise, then fix the pastel before proceeding to step 3.*

3 *Change colour and, using the pastel point, add the fence. Open your eyes, check, then close them and add the outlines of the house. Open your eyes, check, then close them and add an outline to the tree. Add the baseline without opening your eyes.*

Reflex drawing

Once you have discovered your ability to draw 'blind' your eyes are free to observe objects without being distracted or inhibited by the marks you make on the paper. Reflex drawing teaches the automatic response of hand to eye that gives vitality to a painting.

1 *Starting at the top left, follow a line to the right, then continue down to the next line and work right to left. Work continuously back and forth to the bottom (foreground).*

2 *Work as in the first step, beginning at the top left, or distance, and drawing your line back and forth towards the bottom.*

3 *When you are drawing moving people your eye is more concerned with gesture than with detail. If you use a small sketchbook no one will notice what you are doing.*

Reflex painting

Similar to reflex drawing but using a broader method, reflex painting is a useful way of making a quick statement of shapes and giving simple colour reference. Begin by using one colour then progress to three as you gain confidence. Adapt my procedure to subject matter you can observe.

1 With my eyes on the landscape I applied yellow, then took a quick look at the paper. Looking back to the scene I applied green, checked its position then incorporated the line and added the red detail.

2 Again, I applied yellow first, then green and finally red, checking my position on the paper between each colour. I looked at the paper while I added the line.

3 As before, the colours were put in working from light to dark, checking positions between each colour. Line was added only where the colours did not describe the shapes unaided.

COLOUR MIXING

Pastel is a dry medium with an extensive choice of ready-made colours. However, if you have not experienced the mixing of colours or understood the relationships that exist between them, you will not be able to select or use ready-made colours successfully.

Orange is a secondary colour made from warm yellow and warm red. Apply it thinly for a pale colour. Add a touch of blue and use it thinly for a greyed orange or densely for a brown.

Red, cool or warm, is a primary colour. Apply it thinly for a pink. Add a touch of green (blue and yellow) and use it thinly for greyed pink or densely for dark red.

Purple is a secondary colour made from cool red and warm blue. Apply it thinly for a lilac and densely for a darkened colour.

Yellow, cool or warm, is a primary colour. Apply it thinly for a pale yellow. Add a touch of purple (red and blue) and use it thinly for a greyed yellow or densely for darkened yellow.

Green is a secondary colour made from cool blue and cool yellow. Apply it thinly for a pale green. Add a touch of red and use it thinly for greyed green or densely for dark green.

Blue is a primary colour. Buy a warm and a cool blue. Apply colour thinly for pale blue; add small amounts of red and yellow for dark blue and thinly applied darkened blue for grey.

Colour exercises

With these exercises you will create your own colours from two blues, two yellows and two reds. They will show you how colours relate and provide guidance when you shop for pastels. I made flower shapes but you may wish to work more simply. The colour names are for guidance only.

1 *Warm blue (left) has a slight purple appearance (French Ultramarine No. 8); Cool blue (right) tends towards green (Coeruleum No. 8).*

2 *Warm yellow has a slight orange appearance (Cadmium Yellow Hue No. 6). Make two identical samples as shown here.*

3 *Lightly apply warm blue, overlay with warm yellow and blend (left). Lightly apply cool blue, overlay with warm yellow and blend (right).*

1 *Warm and cool blue, as shown in step 1 on the facing page.*

2 *Cool yellow has a tendency towards green. Make two identical samples as shown here (Lemon Yellow No. 6).*

3 *Lightly apply warm blue, overlay with cool yellow and blend (**left**). Lightly apply cool blue, overlay with cool yellow and blend (**right**). The purest greens are made from cool blues and cool yellows.*

On the previous two pages you learnt how a permutation of blues and yellows will create a choice of green. Use the same procedure with reds and yellows to make oranges. Lay a lighter colour over a darker one as it will make them easier to blend, and apply darker colours less generously.

1 *Cool red has a purple bias. Make two identical samples as shown (Rose Madder No. 6).*

2 *Make samples of warm yellow (**left**, Cadmium Yellow Hue No. 6) and cool yellow (**right**, Lemon Yellow No. 6).*

3 *Lightly apply cool red, overlay with warm yellow and blend (**left**). Lightly apply cool red, overlay with cool yellow and blend (**right**).*

1 *Warm red has an orange bias. Make two identical samples as shown here (Poppy Red No. 8).*

2 *Make samples of warm yellow and cool yellow as on the facing page.*

3 *Lightly apply warm red, overlay with warm yellow and blend (**left**). Lightly apply warm red, overlay with cool yellow and blend. You have now made four varieties of orange.*

These colour exercises need time and care, but once they are completed you will not need to mix your own pastel colours again; you will be able to buy them ready-made with the knowledge of how to select them and how to compose a colour scheme.

1 *Make two identical samples of cool blue as shown here (Coeruleum No. 8).*

2 *Make samples of warm red (**left**, Poppy Red No. 8) and cool red (**right**, Rose Madder No. 6).*

3 *Lightly apply cool blue, overlay with warm red and blend (**left**). Lightly apply cool blue, overlay with cool red and blend (**right**). Greenish-blue and orangey-red contain traces of yellow, thus making a purple-brown.*

1 *Make two identical samples of warm blue as shown here (French Ultramarine No. 8).*

2 *Make samples of warm red and cool red as on the facing page.*

3 *Lightly apply warm blue, overlay with warm red and blend (**left**). Lightly apply warm blue, overlay with cool red and blend (**right**). A cool red and a warm blue make the clearest purple.*

FOREGROUND & DISTANCE

A piece of paper is two-dimensional – it has only height and width. The challenge of painting is to create the illusion of depth, giving it the three-dimensional appearance of reality. You can do this by employing both differences in scale and advancing (warm) and receding (cool) colours.

Identical objects

To practise creating an impression of depth in your picture it is best to begin by experimenting with objects that are of identical size and a simple shape.

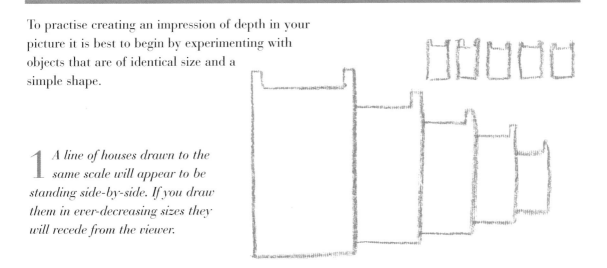

1 A line of houses drawn to the same scale will appear to be standing side-by-side. If you draw them in ever-decreasing sizes they will recede from the viewer.

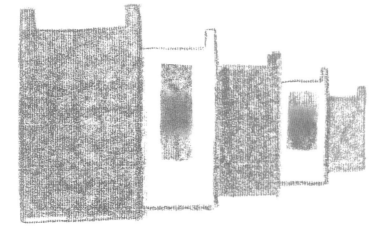

2 Accentuate the effect by using warm colours in the foreground, progressing to cool colours in the background. From the foreground, the sequence here is Burnt Sienna, blended ochre, Sap Green, blended viridian and Coeruleum.

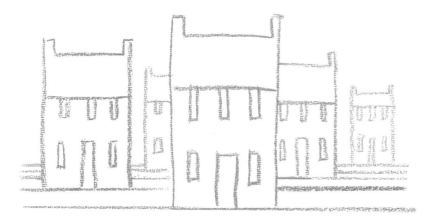

3 Here the houses are arranged more informally. Each one stands on a baseline, and as they recede the intervals between the baseline diminish.

4 The blue line represents your eyeline, which in this instance is from an upper window. It shows that the houses are of similar size and are on level ground. Such construction lines can be erased when they are no longer needed.

5 Detail and contrast become more indistinct with distance. It helps here to view the subject with your eyes half-closed.

LIGHT, SHADE & SHAPE

The depiction of light and shade (tone) helps the viewer's eye to recognize objects and adds solidity to their form. However, painting is made easier if at first you ignore the question of tone and concentrate upon finding the basic shapes of the objects.

From squares to cylinders

Shapes distort when viewed from above or below so it is advisable for beginners to choose a central eyeline, indicated here by a blue line.

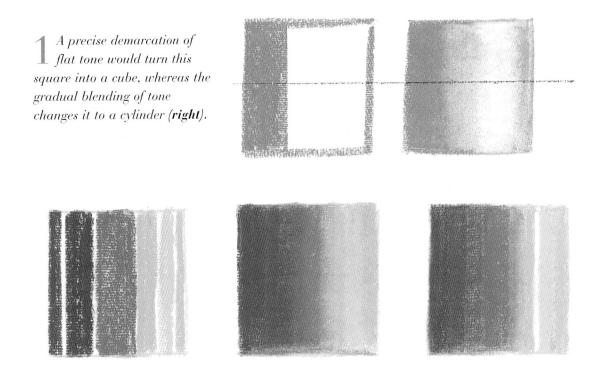

1 *A precise demarcation of flat tone would turn this square into a cube, whereas the gradual blending of tone changes it to a cylinder (**right**).*

2 *For a cylindrical shape, paint a wide band of colour. Add progressively darker or lighter narrowing bands to either side (**left**)* *and blend. Solid colour gives the appearance of a matt surface (**centre**), while leaving some white paper gives a glossy effect (**right**).*

Triangles, pyramids and cones

As with squares, cubes and cylinders, triangular shapes distort when seen from an angle. Again, choose a central view as shown here by the blue line.

1 *This triangle looks like a pyramid when divided into two flat areas of tone (**left**). With the tone gradually blended, the same shape becomes a cone (**right**).*

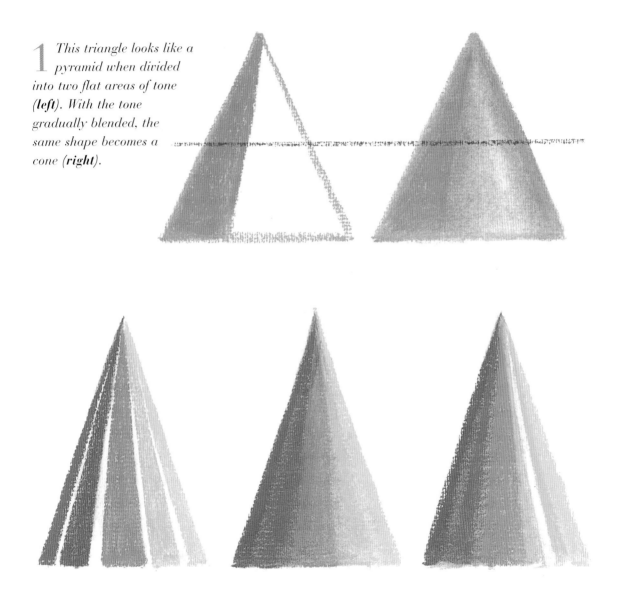

2 *Tonal changes radiate from the top of a cone. Place the widest central band of colour first, followed by the lightest and darkest tones to either side (**left**). Blend the colours, covering the paper entirely for a matt surface (**centre**) and allowing some white paper to show through to give the appearance of a glossy surface (**right**).*

Circles and spheres

Unlike square and triangular shapes, circular objects retain their shape whatever position they are viewed from. Consequently, there is no need to establish a particular eye level.

1 *Draw a circle, then add sections either side of a central axis (**centre**) or radiate them from any point, flattening them on the opposite side (**far right**).*

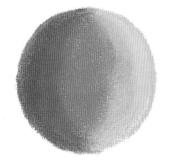

2 *Infill the colours, graduating the tone and covering the paper entirely for a matt surface (**left**) or lifting a highlight for a glossy one (**right**).*

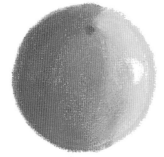

3 *The angle of light from the top of an object to its baseline will determine the length of a cast shadow. The illustration on the left shows the shadow cast at noon. In the illustration on the right, the time could be either mid-morning or mid-afternoon.*

Combining shapes

Most objects consist of a combination of triangular, rounded or squared shapes. Make diagrammatic drawings of the domestic items that surround you, taking care when establishing your eye level (shown here by a blue line).

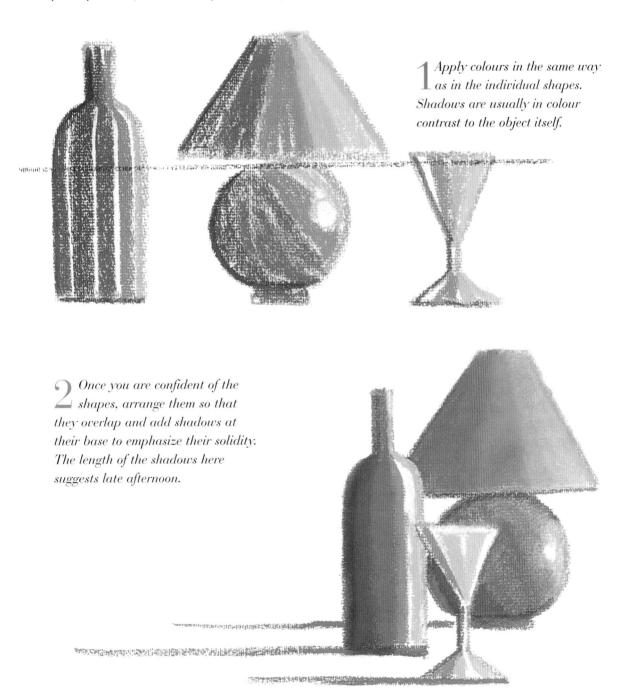

1 *Apply colours in the same way as in the individual shapes. Shadows are usually in colour contrast to the object itself.*

2 *Once you are confident of the shapes, arrange them so that they overlap and add shadows at their base to emphasize their solidity. The length of the shadows here suggests late afternoon.*

EXPLORING PLANTS

Although a daisy may look very different to a rose, for example, leaves, petals
and stems share basic biological characteristics and structures. Begin by
choosing simple shapes and making preliminary line drawings from a flat
viewpoint. From there you can progress to more complex shapes and angles.

Simple leaves

Choose three tones of one colour for this basic leaf shape. I have used yellow-green, but red or
orange would be equally appropriate.

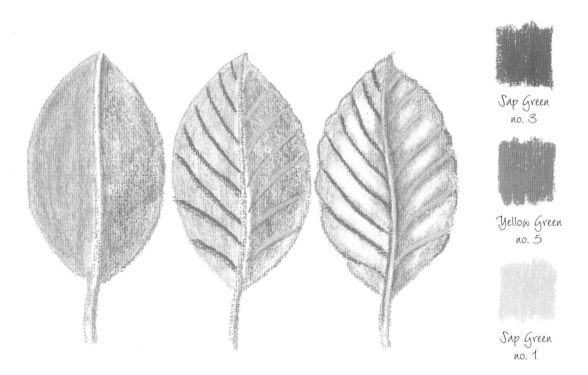

Sap Green
no. 3

Yellow Green
no. 5

Sap Green
no. 1

*The crease along the central spine of a leaf
creates a division of light and shade. Draw the
shape first, fill with close hatching and then
fix (**left**). Next, place the veins alternately on*
*either side, using dark on light and light on
dark (**centre**). If the surface of the leaf is
glossy, lift out highlights between the veins
using an eraser (**right**).*

Curving leaves

Leaves often fold and curve and by doing so show both their upper and under surfaces. If you observe them carefully they are no more challenging to paint than a flat leaf.

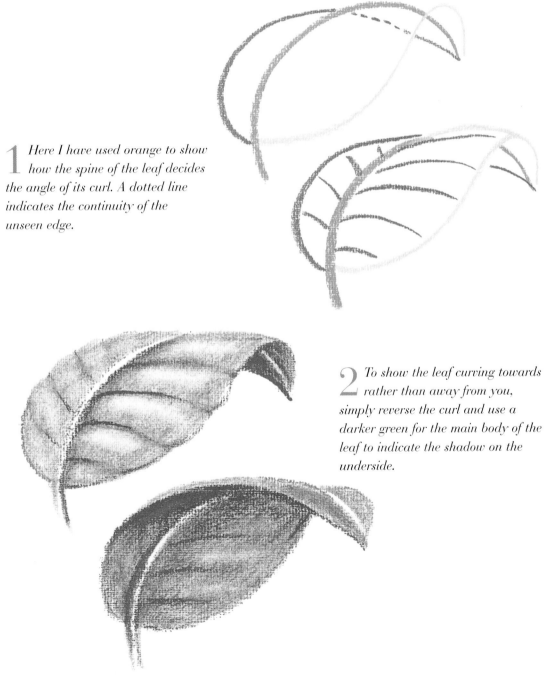

1 *Here I have used orange to show how the spine of the leaf decides the angle of its curl. A dotted line indicates the continuity of the unseen edge.*

2 *To show the leaf curving towards rather than away from you, simply reverse the curl and use a darker green for the main body of the leaf to indicate the shadow on the underside.*

Buds

Flower buds are enclosed by a case of leaves that protect the petals and seedpod. The volume of the closed bud also governs the shape of the subsequent seedpod.

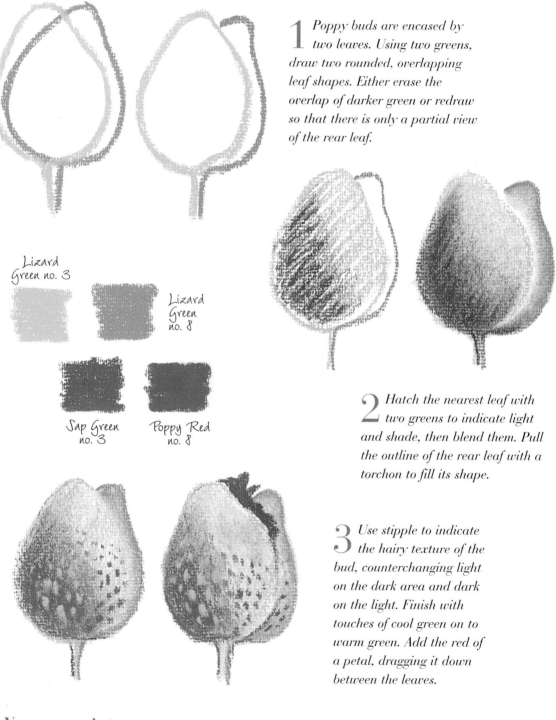

Lizard
Green no. 3

Lizard
Green
no. 8

Sap Green
no. 3

Poppy Red
no. 8

1 *Poppy buds are encased by two leaves. Using two greens, draw two rounded, overlapping leaf shapes. Either erase the overlap of darker green or redraw so that there is only a partial view of the rear leaf.*

2 *Hatch the nearest leaf with two greens to indicate light and shade, then blend them. Pull the outline of the rear leaf with a torchon to fill its shape.*

3 *Use stipple to indicate the hairy texture of the bud, counterchanging light on the dark area and dark on the light. Finish with touches of cool green on to warm green. Add the red of a petal, dragging it down between the leaves.*

Seedpods

Many plants have seedpods that are very attractive and longlasting when dried. However, do compare a dried pod with its living equivalent in the centre of a flower.

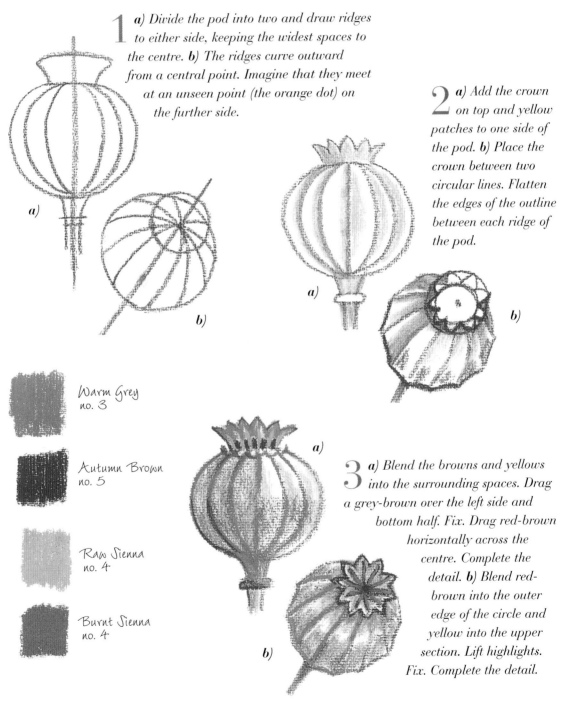

1 *a) Divide the pod into two and draw ridges to either side, keeping the widest spaces to the centre. b) The ridges curve outward from a central point. Imagine that they meet at an unseen point (the orange dot) on the further side.*

a)

b)

2 *a) Add the crown on top and yellow patches to one side of the pod. b) Place the crown between two circular lines. Flatten the edges of the outline between each ridge of the pod.*

a)

b)

Warm Grey no. 3

Autumn Brown no. 5

Raw Sienna no. 4

Burnt Sienna no. 4

a)

b)

3 *a) Blend the browns and yellows into the surrounding spaces. Drag a grey-brown over the left side and bottom half. Fix. Drag red-brown horizontally across the centre. Complete the detail. b) Blend red-brown into the outer edge of the circle and yellow into the upper section. Lift highlights. Fix. Complete the detail.*

Petals

Petals take many forms, from the frilled, complex forms of dianthus to the simple saucer shapes of buttercups. However, they are rarely completely flat, so pay attention to how the light falls on them and alters their colour.

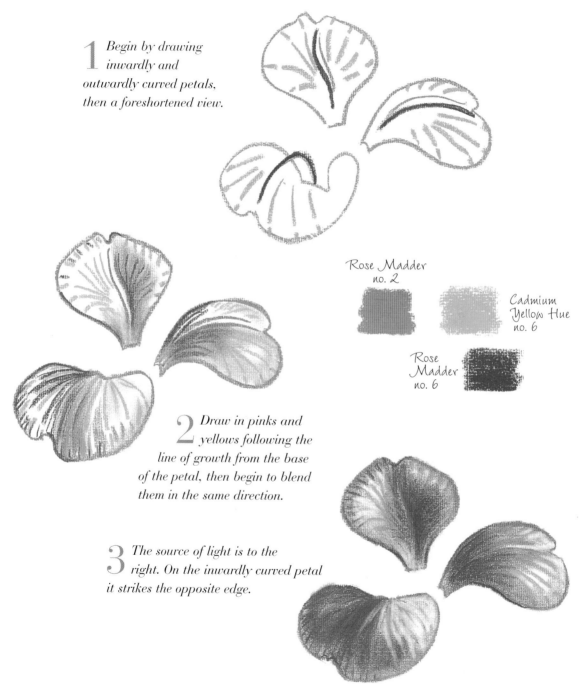

1 *Begin by drawing inwardly and outwardly curved petals, then a foreshortened view.*

Rose Madder
no. 2

Cadmium
Yellow Hue
no. 6

Rose
Madder
no. 6

2 *Draw in pinks and yellows following the line of growth from the base of the petal, then begin to blend them in the same direction.*

3 *The source of light is to the right. On the inwardly curved petal it strikes the opposite edge.*

Stems

A stem can be drawn in a line progressing from thick to thin in one quick movement. With your paper upside down. apply the pastel firmly. releasing pressure as you draw it towards you.

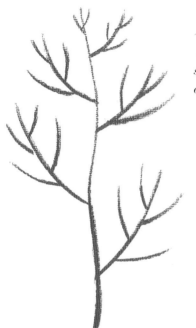

1 *Still working upside down, add alternating side stems. Intervals decrease towards the top.*

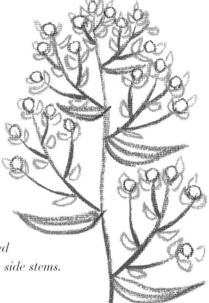

2 *Leaves are often produced where side stems branch from the main stem. This is then repeated along the junctions of the side stems.*

Madder Brown no. 4

Madder Brown no. 6

Cadmium Orange no. 6

Raw Sienna no. 6

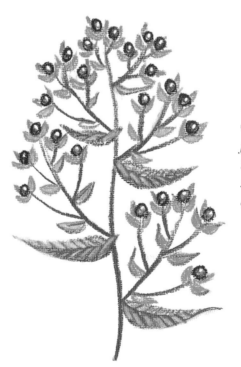

3 *Buds, berries, seedpods and flowers are borne at the tips of the stems, often surrounded by a cluster of small leaves.*

Michaelmas daisy

A many-petalled flower such as Michaelmas daisy is a little trickier than the trio of broad petals on page 40, but there is no need to include every detail. Once you have mastered the individual flower and are familiar with its form, try painting the whole plant.

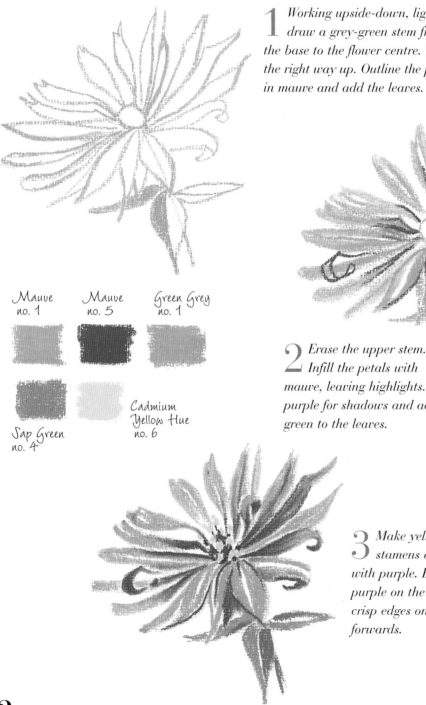

1 Working upside-down, lightly draw a grey-green stem from the base to the flower centre. Turn the right way up. Outline the petals in mauve and add the leaves.

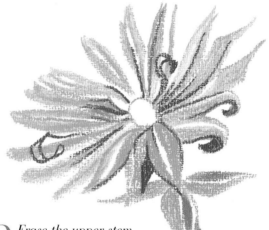

Mauve
no. 1

Mauve
no. 5

Green Grey
no. 1

Sap Green
no. 4

Cadmium
Yellow Hue
no. 6

2 Erase the upper stem. Infill the petals with mauve, leaving highlights. Use purple for shadows and add sap green to the leaves.

3 Make yellow dots for stamens and surround them with purple. Blend mauve into purple on the petals but keep crisp edges on those facing forwards.

1 *Draw the branching stem in grey-green. Plot the positions of the flowerheads so that they are seen full face, in profile or from the rear. The outlines can be removed later with an eraser.*

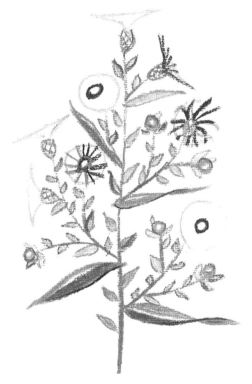

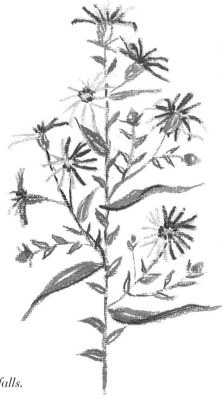

2 *Side stems have extra leaves as well as those at the junction of the stems. Crisscross the seedpods and begin to add structure to the flowerheads.*

3 *Flesh out the detail on the flowerheads, using darker mauve to show where shadow falls.*

Poppies

Poppies are endearingly attractive with their hairy stems, ragged leaves and blowsy, crumpled petals, but beneath the apparent untidiness and fragility of the flowers there is a governing structure that you need to observe carefully.

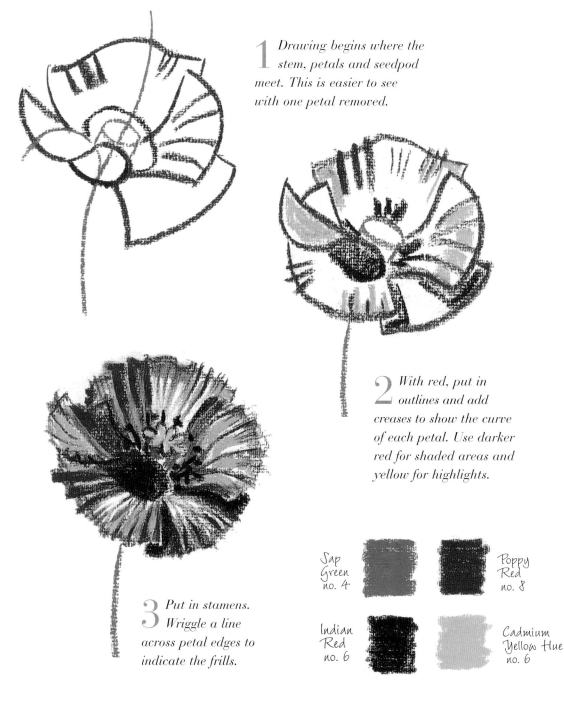

1 Drawing begins where the stem, petals and seedpod meet. This is easier to see with one petal removed.

2 With red, put in outlines and add creases to show the curve of each petal. Use darker red for shaded areas and yellow for highlights.

3 Put in stamens. Wriggle a line across petal edges to indicate the frills.

Sap Green
no. 4

Poppy Red
no. 8

Indian Red
no. 6

Cadmium Yellow Hue
no. 6

1 *You will find it easier to paint spiky poppy leaves if you first look at the underlying structure and placing on the stem. They become smaller towards the top.*

2 *With tracing paper, follow the lines of your initial drawing, adding spiky edges. Draw the tops of smaller leaves across the stem to indicate twists and turns.*

3 *Infill the greens, using a darker tone on the underside of the leaves where they are in shadow.*

4 *Now combine the flower with the leaves, remembering to start the flower with a single line of stem. Overlay it with the leaf stem, balanced in the opposite direction. Develop the leaf by adding a third green but keep an open texture to suggest hairs. You can add these to the stem by lightly scratching with a scalpel.*

DEMONSTRATION POPPY

AT A GLANCE...

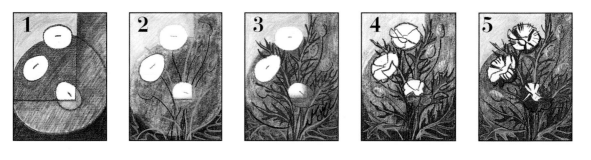

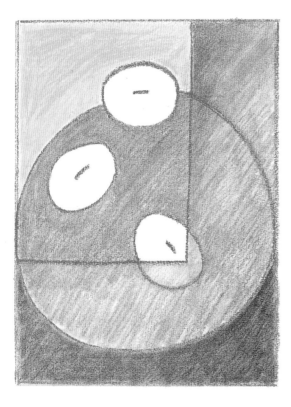

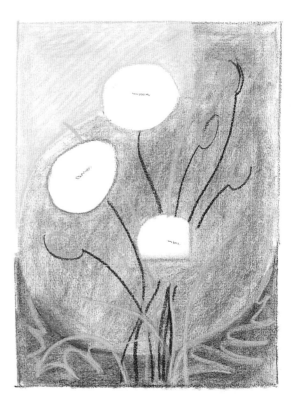

1 The main interest is created by contrasts, so extremes of red, green, light and dark are concentrated in one area. The L shape plays only a supporting role. Drag and blend yellow, sap green and olive green for the background.

2 Use olive green to draw the stems of buds and flowers and the edges of the buds that are furthest from the light. Draw the leaf stems and the outlines of buds in warm yellow. Use yellow-green for the leaves at the bottom.

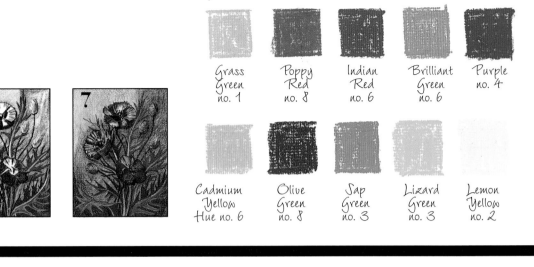

Grass
Green
no. 1

Poppy
Red
no. 8

Indian
Red
no. 6

Brilliant
Green
no. 6

Purple
no. 4

Cadmium
Yellow
Hue no. 6

Olive
Green
no. 8

Sap
Green
no. 3

Lizard
Green
no. 3

Lemon
Yellow
no. 2

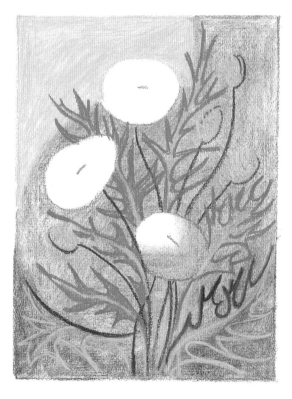

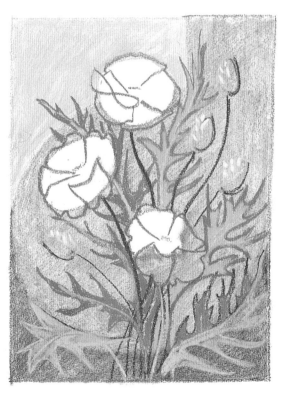

3 Draw the upper edges of the two foreground poppy leaves with olive green. Use sap green for the remaining leaves and infill the three on the left of the stem. Hatch the half of each bud that is nearest the light in yellow. Fix.

4 Highlight buds with lightest yellow. Partially infill foreground leaves with yellow-green. Complete the upper half of the leaf at bottom right with sap green and the remaining leaves with a pale blue-green. Draw outlines of petals.

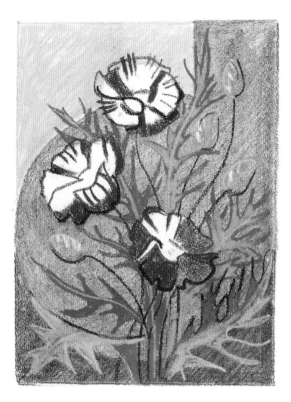

5 Infill a small area of sap green to the base
of the left-hand foreground leaf. Infill the
red of the poppies, leaving areas of white, and
draw folds on the petals. Drag the pastel,
allowing any green to show through, especially
on the lower flower. Outline shadow areas with
dark red.

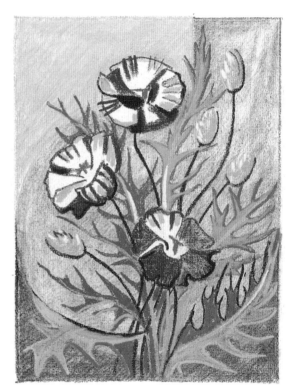

6 Blend and infill the dark red shadows.
Place light blue-green on the shaded sides
of the buds and use brightest green for the
seedpods in each flower. Place reflected
yellows between the folds of the petals and
highlight the two leaf stems in the centre of the
picture with lightest yellow. Add red to the
left-hand bud.

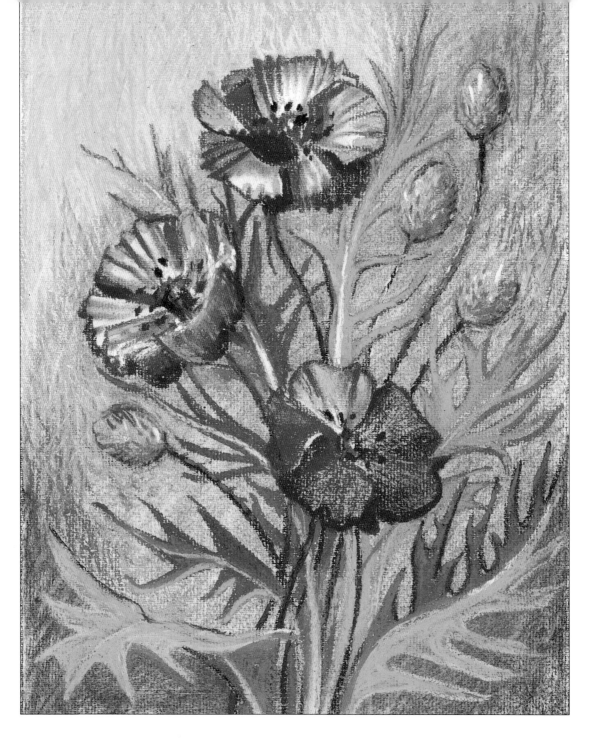

7 *Finished picture: 29 x 21.5cm (11½ x 8½in).*
Soften the background by feathering green on yellow and yellow on green so that edges blend. Stipple the buds and stems to give them texture and tone. Blend the leaves and the flowers. Stipple in the stamens and accentuate the contrasts of light and dark at the centre of each flower, setting purple against white and brightest green against red.

STILL LIFE

The fruits and vegetables on these pages have been selected for their pattern or texture. Search out your own collection, choosing a variety of rough, smooth, ridged or dimpled surfaces. Gourds, nuts, cones and vegetables are all fruits of plants, so do not limit yourself to the grocery trade's definition of fruit.

Marrow

No two marrows have the same pattern, and the one here looks as if it has scribbles on it as well as stripes. Notice how the pattern helps to describe the shape.

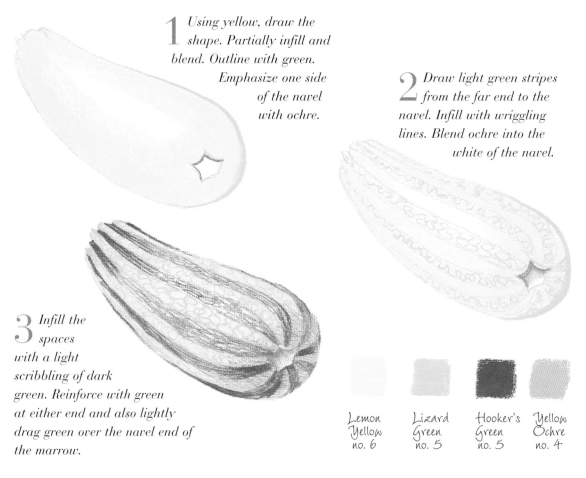

1 Using yellow, draw the shape. Partially infill and blend. Outline with green. Emphasize one side of the navel with ochre.

2 Draw light green stripes from the far end to the navel. Infill with wriggling lines. Blend ochre into the white of the navel.

3 Infill the spaces with a light scribbling of dark green. Reinforce with green at either end and also lightly drag green over the navel end of the marrow.

Lemon Yellow no. 6

Lizard Green no. 5

Hooker's Green no. 5

Yellow Ochre no. 4

Orange

Oranges are simple in shape and painting one is very much like doing the exercise on page 34. However, you need to take care over the textured feel of the skin as casual stippling could have a flattening effect. Notice how the stippling is flatter and thinner at the circumference.

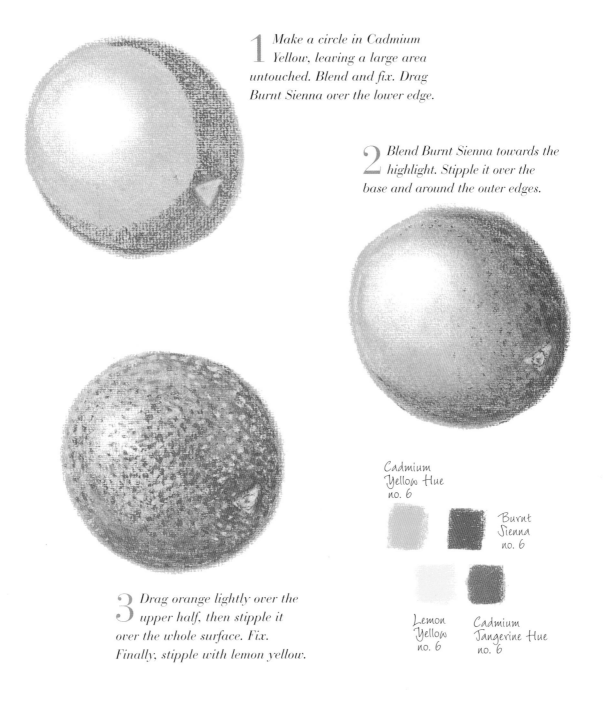

1 *Make a circle in Cadmium Yellow, leaving a large area untouched. Blend and fix. Drag Burnt Sienna over the lower edge.*

2 *Blend Burnt Sienna towards the highlight. Stipple it over the base and around the outer edges.*

3 *Drag orange lightly over the upper half, then stipple it over the whole surface. Fix. Finally, stipple with lemon yellow.*

Cadmium Yellow Hue no. 6

Burnt Sienna no. 6

Lemon Yellow no. 6

Cadmium Tangerine Hue no. 6

Plums

Plums have no pattern to describe their shape and no obvious texture, but if you look carefully you will often find that the skin has a bloom to it. This is texture in its subtlest form, shown by gently dragging a light colour over a dark one.

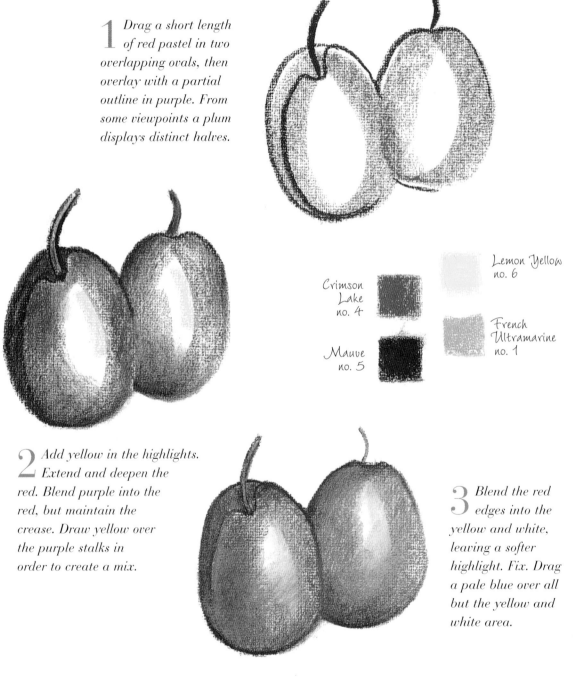

1 *Drag a short length of red pastel in two overlapping ovals, then overlay with a partial outline in purple. From some viewpoints a plum displays distinct halves.*

Crimson Lake no. 4

Mauve no. 5

Lemon Yellow no. 6

French Ultramarine no. 1

2 *Add yellow in the highlights. Extend and deepen the red. Blend purple into the red, but maintain the crease. Draw yellow over the purple stalks in order to create a mix.*

3 *Blend the red edges into the yellow and white, leaving a softer highlight. Fix. Drag a pale blue over all but the yellow and white area.*

Fir cone

The previous examples of fruit have had either pattern or texture, but fir cones have both. Here the pattern not only describes the shape of the object but also controls the way it feels. Handle fir cones before you begin to draw them so that you understand their texture.

1 Draw a blue outline. Make curved stripes from top left, then cross with stripes from the right. Draw in arrow shapes.

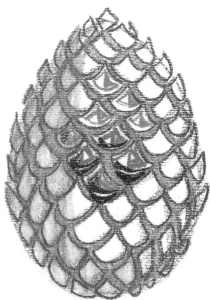

2 Infill the spaces between the 'arrows' with blue, covering the original lines. Drag and blend blue over the left side and base before infilling the 'arrows'.

Prussian Blue no. 3

Cadmium Orange Hue no. 6

Madder Brown no. 8

Cadmium Yellow Hue no. 6

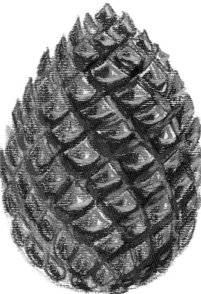

3 Fix, then apply outlines of orange, infilling to one side and underlining with brown. Emphasize the depths at the centre of the cone with blue and highlight projections with yellow.

AT A GLANCE...

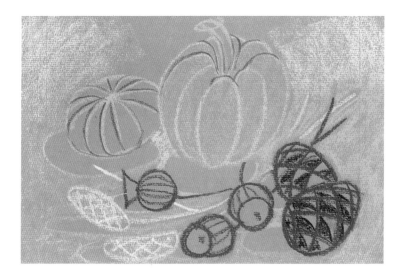

1 Arrange the objects in a
 still life so that interest
is spread throughout the
group. Here the twisted
stalk of the large gourd
directs the viewer's eye to
the smaller gourd, from
where the circular
arrangement leads through
the corn stalks, poppy pods
and fir cones back to the
starting point.

2 In this group a green-
 yellow-orange harmony
has been chosen, with purple
grey as a contrast. Lightly
infill the colours, leaving
large areas of sand-coloured
paper showing. The colour
interest lies mainly in the
large items in the upper
section, while the darker
tones at the base provide
stability and weight.

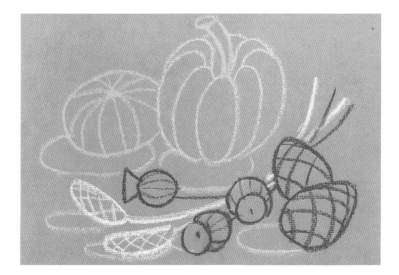

Cadmium
Yellow Hue
no. 4

Lizard
Green
no. 3

Lemon
Yellow
no. 2

Red
Grey
no. 6

Purple
Grey
no. 6

Cadmium
Orange
Hue no. 6

Brilliant
Green
no. 6

Hooker's
Green
no. 8

Lemon
Yellow
no.6

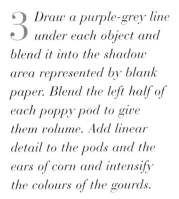

3 Draw a purple-grey line under each object and blend it into the shadow area represented by blank paper. Blend the left half of each poppy pod to give them volume. Add linear detail to the pods and the ears of corn and intensify the colours of the gourds.

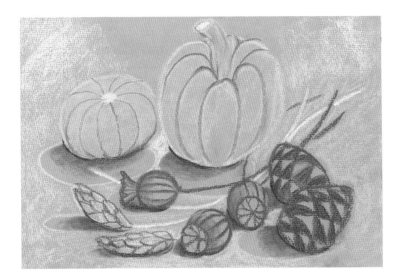

4 Blend the shadow area of each fir cone, intensify tonal contrasts and create spikes by dragging the surrounding green into the outer edges of the cones. Apply surface pattern to each gourd, following the curving lines. Add purple detail to the seedpods, then touches of orange to the nearest one and to the fir cones. Lightly fix before attending to the final details.

You can paint 55

5 *Finished picture:* 25 x 34 cm (9¾ x 13½ in).
Add yellow highlights to the gourds and
to the poppy pods and fir cones. Add brighter
yellow patches to the ears of corn. Blend the
yellow background into the blank paper at the
top (further) edge and feather orange into the
bottom (nearer) edge.

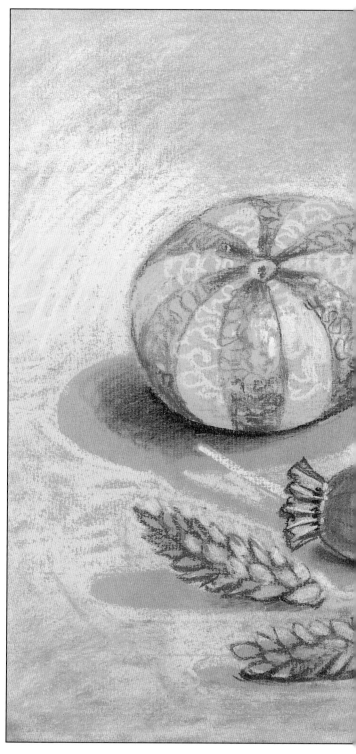

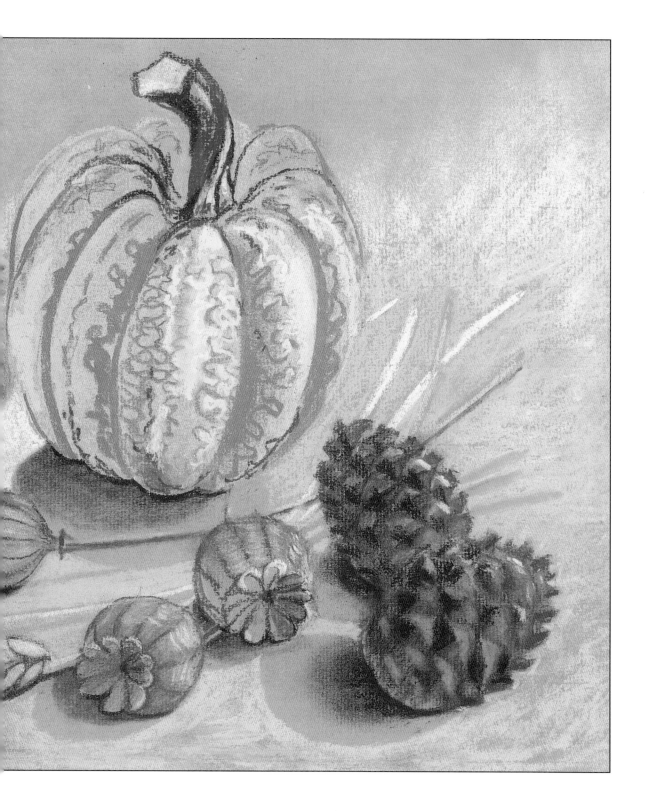

TREES

In a sketchbook, make brief studies of various species of tree through the year. Concentrate on just one aspect at a time, beginning with shape and working through scale, form, structure, character and development in that order.

Shape and scale

Comprehensively record basic shapes and make a note of species and of location – a tree growing on an exposed, windy site will look different to one of the same species in a dense forest.

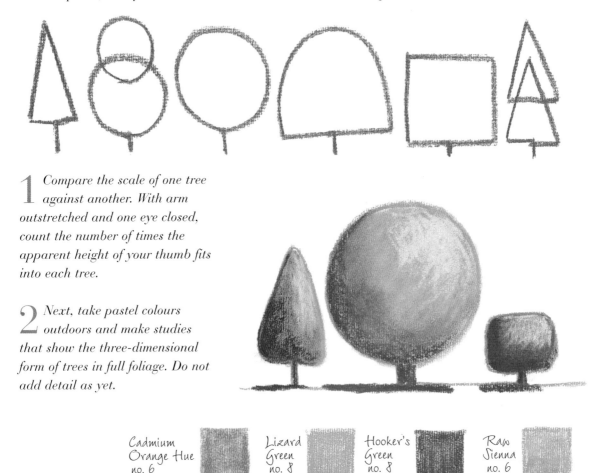

1 *Compare the scale of one tree against another. With arm outstretched and one eye closed, count the number of times the apparent height of your thumb fits into each tree.*

2 *Next, take pastel colours outdoors and make studies that show the three-dimensional form of trees in full foliage. Do not add detail as yet.*

Cadmium Orange Hue no. 6

Lizard Green no. 8

Hooker's Green no. 8

Raw Sienna no. 6

Structure and character

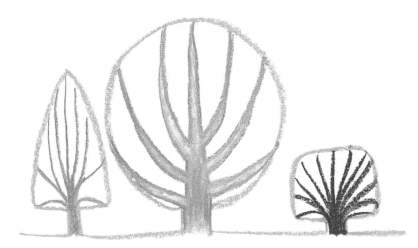

1 *Study deciduous trees in winter, when you can see their skeletons. Ideally, branches alternate in order to gain equal light. Try to find trees with a straightforward branching system to give you an easy basis for study.*

2 *Saplings adapt to accidents and weather. A perfect tree gives you the easiest start but a weathered tree has the character that motivates a painting.*

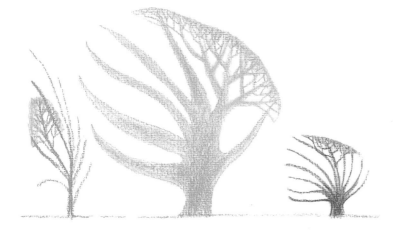

3 *Main branches have lesser branches following the same growing system. This pattern repeats itself on an ever-decreasing scale within the outer tree shape.*

Developing a tree

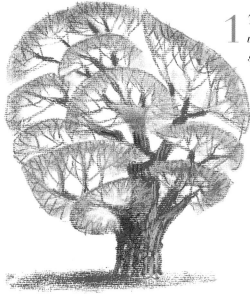

1 The time to start studying trees is in winter, when you can clearly see the branching system. Twigs mass into clearcut shapes; lightly drag a pastel along the outer edges.

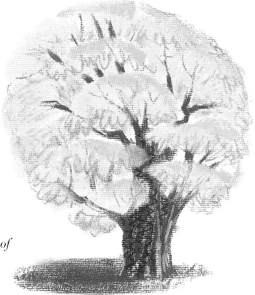

2 Fix the first stage, then drag a thin veil of foliage colour over each mass of twigs. Lightly stipple. Emphasize tonal contrasts in the branches and trunk rather than in the foliage.

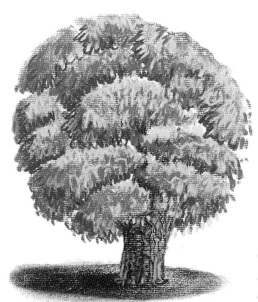

Sap Green no. 6	Grass Green no. 6	Purple Brown no. 6	Poppy Red no. 8
Hooker's Green no. 8	French Ultra-marine no. 1	Lemon Yellow no. 6	Cadmium Yellow Hue no. 6

3 Drag a shadow to one side of the tree. Fix. Stipple darker colour on the underside of each foliage mass, lighter on the lit side and brighter colour in the centre.

Seasonal trees

1 *Once you have learnt to construct a tree, seasonal changes are then a matter of selecting one of the three stages as your method and matching the appropriate colours. Winter trees are usually simple in colour, the emphasis being on their tonal contrasts.*

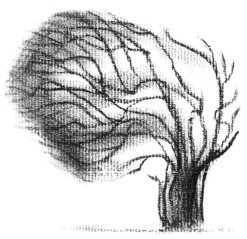

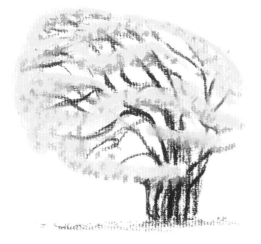

2 *The thinly clad framework in step 2 on the facing page is appropriate for spring or autumn; the difference is that of colour. Observe the light green haze of spring foliage and autumn colours as leaf fall begins to reveal the underlying tree.*

Terre Verte Hue no. 8

Yellow Green no. 3

Lemon Yellow no. 6

Grass Green no. 6

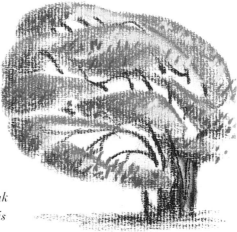

3 *A summer tree is relatively easy provided you construct its framework first. Not all species have such concealing foliage as the oak shown opposite; in a hawthorn the structure is visible all year round.*

Leaves and fruit

Outdoor sketches of overall shape are done
quickly, but botanical examples allow leisurely
study at home. Such details are unnecessary for
painting a tree in its entirety but they give vital
understanding of the subject.

*1 Draw outlines in
colours characteristic
of each set of berries,
cones, buds and flowers.
Note how they compare
with each other in scale.*

*2 Infill the outlines, extending
the colour range. The
examples here show summer and
autumn leaves on one twig, but
ideally you should make separate
seasonal studies.*

Cadmium Yellow Yellow Indian
Yellow Green Ochre Red
Hue no. 6 no. 5 no. 6 no. 6

*3 Complete the study by blending
and overlaying with stronger
colours. Be aware of tonal contrasts
of light and dark, saving highlights
from the start.*

1 *Using the same method as on the facing page, draw details of a less densely foliaged tree such as a hawthorn. Small, openly spaced leaves on a twig indicate a tree that has only a light foliage canopy.*

2 *Lightly infill the leaves with colour, reserving half of each. Infill the berries, saving highlights.*

3 *Complete the infilling of the leaves, intensifying tonal contrasts. Strengthen the berries, being careful to preserve their highlights. Finally, add the long, spiny thorns.*

Purple Brown no. 6

Poppy Red no. 8

Yellow Green no. 5

Hooker's Green no. 8

Cadmium Yellow Hue no. 6

EXERCISE Paint a tree

From the studies you have made of trees, select one in a very simple landscape with level ground and a preponderance of sky such as is shown here. Using a mid-toned paper will help you to balance light and dark tones successfully from the outset.

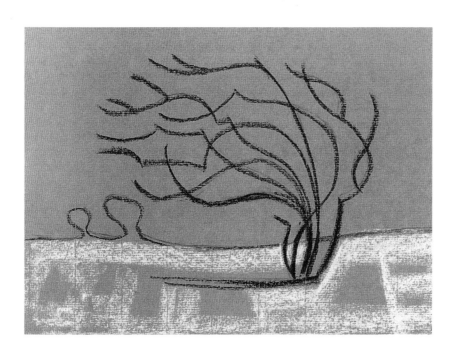

1 *Draw a line for the horizon then draw the tree from its base upwards, paying attention to getting its overall shape right. Drag a light colour over the ground, leaving some areas of the paper blank.*

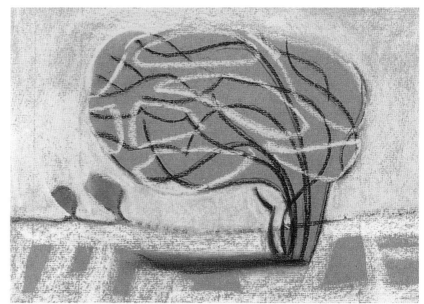

2 *Drag the palest colour you are using over the sky – it doesn't have to be blue. Draw the shapes of the foliage masses. You can add distant trees on the horizon by simply blending them from an outline. The shadow beneath the main tree can be put in using the same method.*

| Prussian Blue no. 5 | Lemon Yellow no. 6 | Cobalt Blue no. 0 | Lizard Green no. 5 | Hooker's Green no. 5 | Hooker's Green no. 8 | Lemon Yellow no. 2 | Cadmium Yellow no. 6 |

3 *Lightly infill the foliage, leaving some blank paper. Stipple in light colour at the edges of the foliage masses where the light catches them and then apply a mid-green to the centre and a darker one below. Infill the spaces between them with the sky colour.*

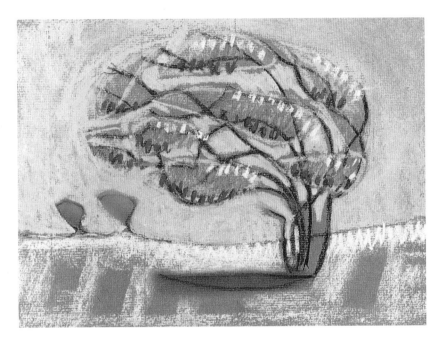

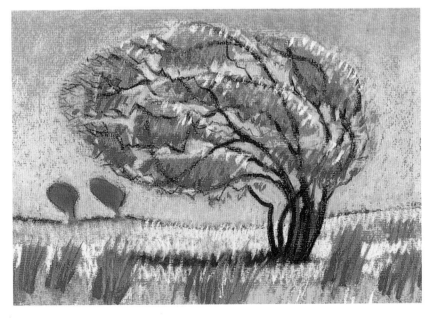

4 *Apply vertical strokes of warmer colour to the mid-ground and then warmer still at the foreground. Stipple similar colour on the foliage to give unity. Intensify the sky colour at the horizon. Finally, put in the foreground rushes with two tones of green.*

You can paint 65

SKIES

A sky is constantly in a state of change, so you are free to depict it in abstract shapes without fear of them being considered to be 'wrong'. You will already have experienced this natural and relaxed way of painting by doing the exercises on pages 16–21.

A sky sketchbook

Keeping a sky sketchbook will help you to handle pastels with confidence. Produce one study a day and note the time and date.

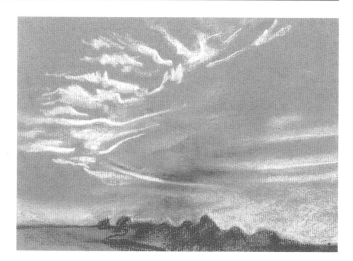

This is one of a set of studies made early each morning from my bedroom window, using white and grey pastels and a sketchbook with paper of assorted colours.

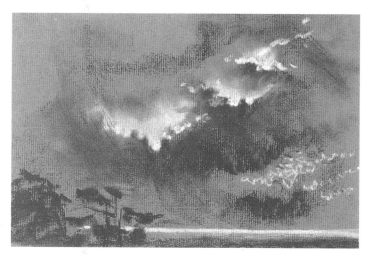

Make a study at the same hour for three weeks. Select paper of a colour to match the general tone of the sky and use white for highlights and grey for darker tones.

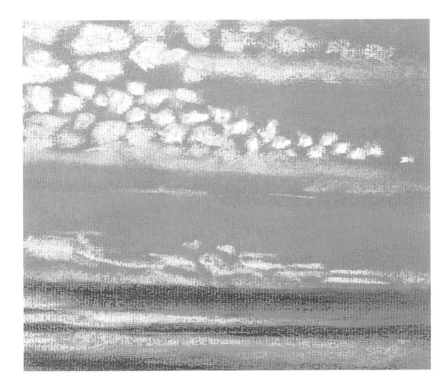

After a few days add a coloured pastel to the white and the grey. Lay the broadest bands of pastel first, finishing with the smaller details. Here pale blue was followed by grey and then white. While not an absolute rule, it is usually more effective to leave white until last.

In this sketch grey was applied first, leaving a thin line at the horizon. It was followed by blue, yellow and white. You will not find drama in the sky every day, but low cloud cover will give you practice in blending an even tone on the paper.

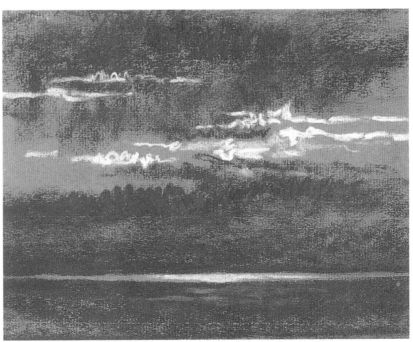

Skies on location

Try making sky studies when you are on the move – watching skies from the windows of a train offers an excellent opportunity. Here white was applied before grey. They were blended together before further accents of white were added to the tops of clouds.

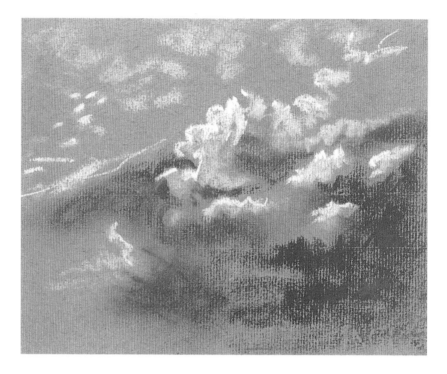

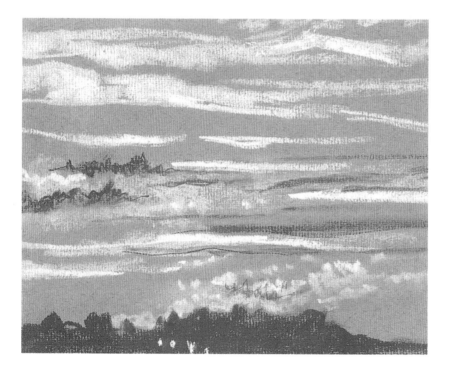

If you are tempted to record architectural or landscape features keep them simple and just add some written notes or you will become lost in detail. Dawn and dusk are good times for sky studies as the land is largely lost in the dim light.

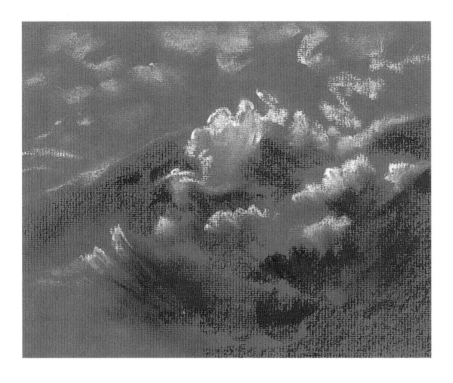

When you return home from a journey, play with your studies. Experiment with reproducing the sketches using the same pastels but on papers of different tones and colours. You will find that you are able to change the mood of the subject.

Changing the background will also encourage you to explore different methods of creating the effects you want. Here, on dark-toned paper, streaks have been lifted with an eraser while on mid-toned paper they were drawn direct.

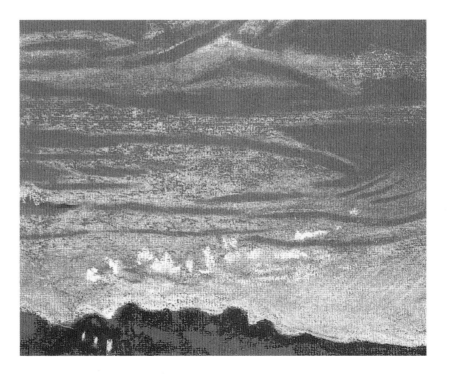

Paint a sky

The sky is nearest to the viewer at the top edge of the paper. It recedes in decreasing planes to its furthest distance at the horizon, where it meets the land which has correspondingly been closest to the viewer at the bottom edge of the paper.

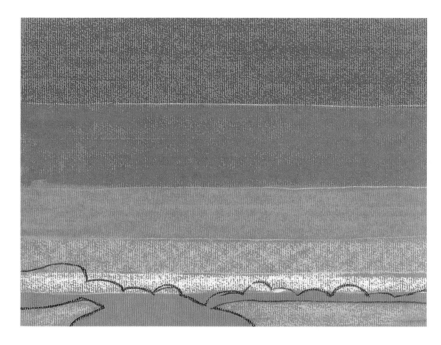

1 *Divide the paper from its top edge into bands of colour that grow successively lighter, cooler and narrower as they progress towards the land. Draw trees and fields beneath it.*

2 *Blend the sky so that the edges of the colours merge imperceptibly into one another. Infill and blend the yellow-green of the fields and the purple-grey colour of the trees.*

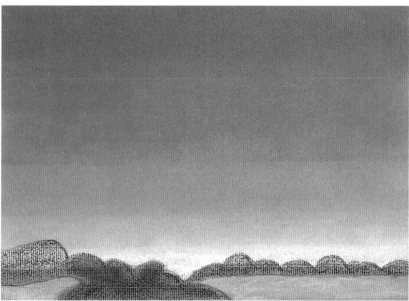

Coeruleum no. 1 Purple Grey no. 6 Sap Green no. 1 Poppy Red no. 1 Silver White Cobalt Blue no. 6 French Ultra-marine no. 3 Indigo no. 1

3 With white, lightly draw a curving grid over the sky so that it radiates from any chosen point on the horizon. Fill each space with the outline of a cloud.

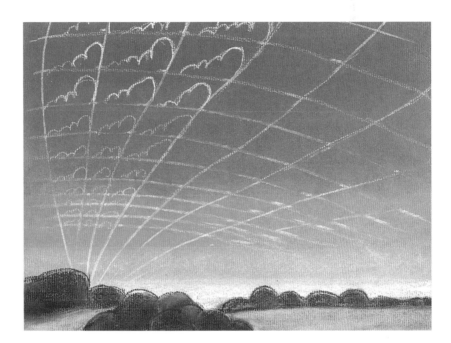

4 Blend the clouds then feather the top edges, giving the crispest whites to those nearest the top of the paper.

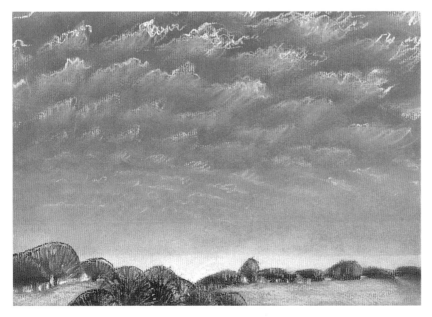

DEMONSTRATION LANDSCAPE

AT A GLANCE...

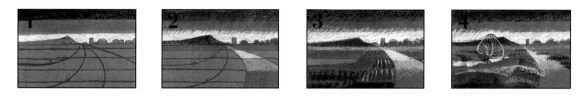

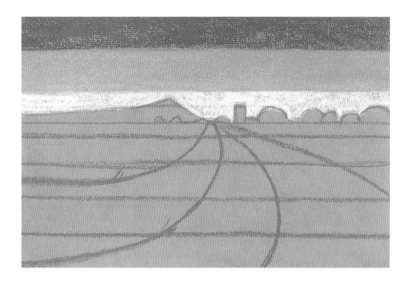

1 A typical landscape combines sky, water, trees, plants and buildings. Taking note of the initial structures, lightly mark the position of focal points, one for distance, another in the middle ground and a third in the foreground. Divide the sky into three bands of blue. Draw the ground planes and add radiating lines to indicate the division of path, verge and river.

2 Drag cool blue for the hill, grey for the trees and tower and light blue for the distant meadow. Colour the path warm yellow in the foreground and graduate cooler yellows as the path stretches into the distance.

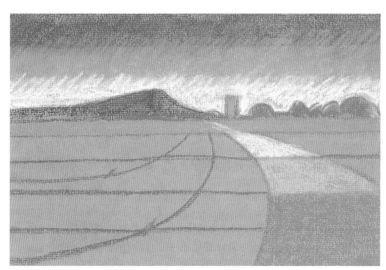

The palette

Burnt Sienna no. 6	Cadmium Yellow Hue no. 6	Yellow Ochre no. 0	Green Grey no. 1

Prussian Blue no. 3	Prussian Blue no. 1	Lemon Yellow no. 6	Yellow Ochre no. 6	Cadmium Orange Hue no. 6

5

3 *Loosely integrate the bands of sky, blend the yellows of the path and drag cool yellow across the blue of the meadow. Fill areas of the middle distance with orange, reserving a space for the river. Use vertical stripes of the yellows, ochre and blue for the foreground spaces and then blend them with a finger.*

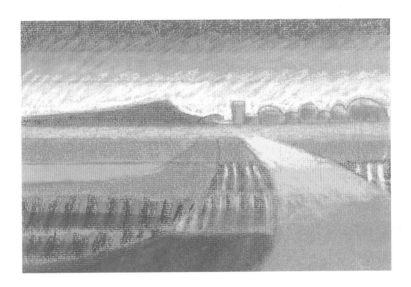

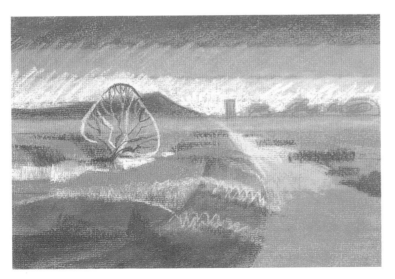

4 *Draw the tree's shape and structure, using light colour against the ground and dark against the sky. Block in highlights and shadows in the verges. Make downward strokes of blues and cream for water.*

You can paint 73

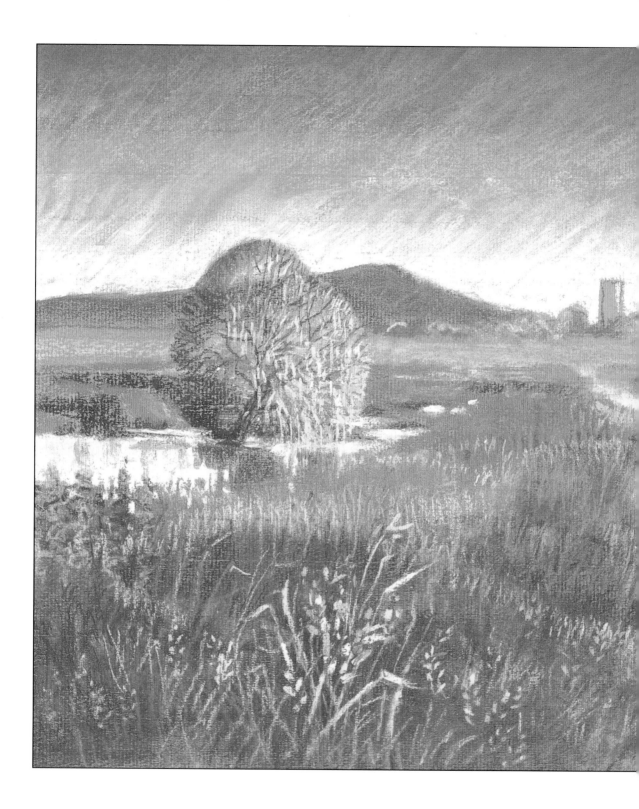

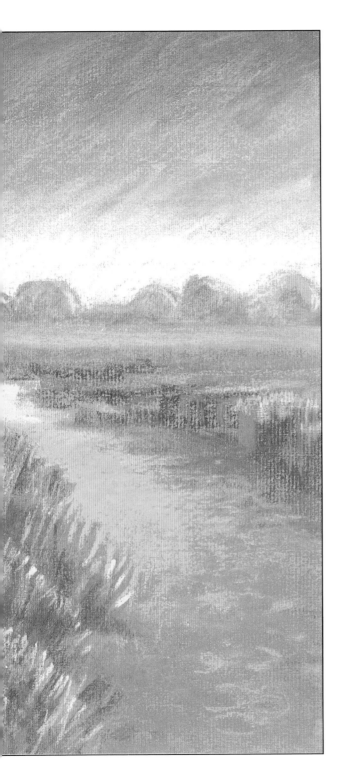

5 *Finished picture:* 25 x 34cm (9¾ x 13½in). Feather the sky, path and hill. Add highlights to the distant view. Build the tree from its winter structure, adding a light autumn cover of vertical strokes. Add the grasses, giving emphasis to those in the foreground.

ANIMALS & PEOPLE

Earlier you practised the reflex drawing of figures (see pages 20–1). All you need to do is to select a few from your sketchbook for use in the following exercises. Animals can be depicted using exactly the same technique of capturing the moving shape without worrying about detail.

Drawing animals

Animals are no more difficult to draw than people. It is easiest to start with domestic animals and garden birds because their forms are so familiar. When you feel ready to explore further, make trips to zoos and country parks.

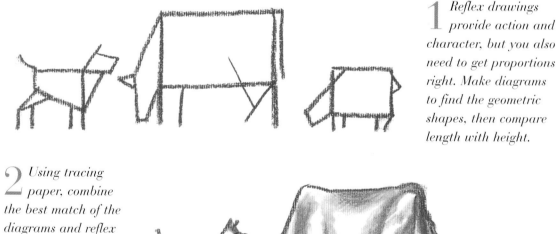

1 Reflex drawings provide action and character, but you also need to get proportions right. Make diagrams to find the geometric shapes, then compare length with height.

2 Using tracing paper, combine the best match of the diagrams and reflex drawings from your sketches. Add tone and colour.

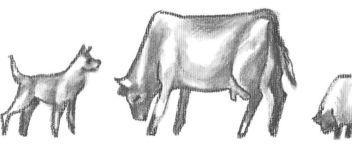

Purple Brown no. 4 Yellow Ochre no. 6 Burnt Sienna no. 6 Indigo no. 3 Poppy Red no. 8

Adding figures

Once you are comfortable with drawing and painting animals, combine them with figures. Overlap the shapes to make a convincing group.

1 *Compare the heights of animals with figures when they stand at the same distance from you. Make repeated sketches with animals of different sizes.*

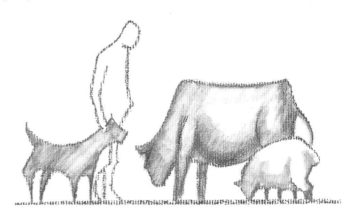

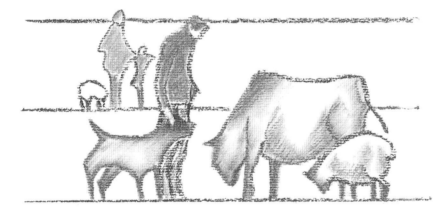

2 *The largest group are positioned on a ground plane nearest the viewer (the bottom line) while the smaller group stand on a more distant plane (the middle line).*

3 *The red, yellow and blue figures are at a different distance from the viewer but they are on the same eye level (the top line).*

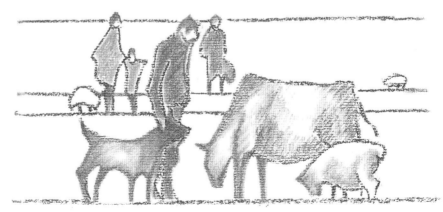

Populate a landscape

Figures, either human or animal, give emotional meaning to a landscape. This scene is convivial, but a solitary figure can suggest more about remoteness than an empty view. Practise with standing figures and level ground at first before tackling more difficult subjects.

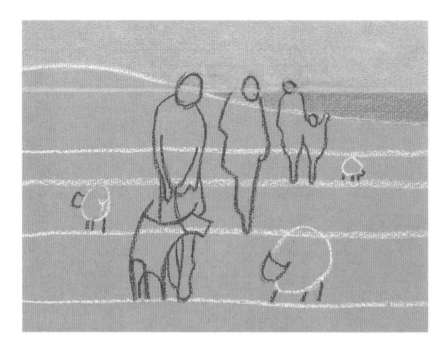

1 *First draw your eye level, which will always coincide with the sea's horizon. On it, place adult heads of varying size. Draw bodies to match the head sizes and indicate the related ground planes, adding a gentle hill. Draw the animals, matching their size to the people.*

2 *Infill the sea, sky and narrowing ground planes between the figures. Use receding colours from ochre to green, leaving grey paper for the distance.*

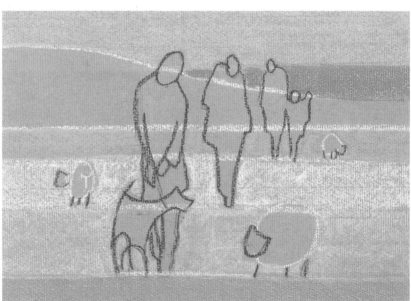

The palette

| Blue Green no. 5 | Purple Brown no. 6 | Yellow Ochre no. 0 | Blue Green no. 1 | Lizard Green no. 7 | Lemon Yellow no. 6 | Cadmium Yellow Hue no. 6 | Cadmium Orange Hue no. 6 |

3 *Infill the animals, leaving grey paper for the underside of the nearest sheep. Use dark colour sparingly, mainly blending it from outlines as this gives a variegated effect and is easier to control. Blend the ground colours together.*

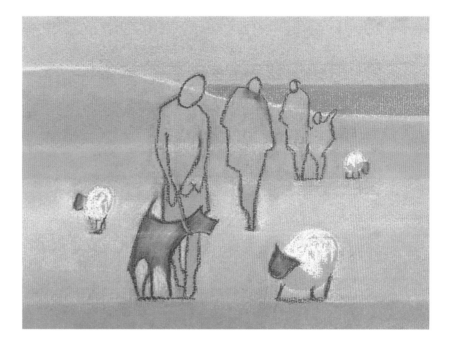

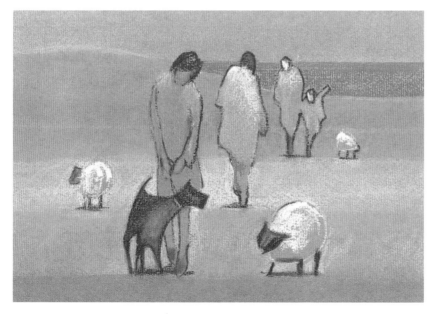

4 *Add minimal colour to the people. Aim to refine your technique of figure drawing, but in the meantime your reflex sketches add movement to the picture. With the scene lit from above, the shadows are directly beneath the figures.*

WATER

Water has no visual identity of its own – it borrows from its surroundings and from the sky. Consequently, the only effective method of painting it is by direct observation from nature and from still-life subjects. In a landscape, remember particularly to match the mood of the sky with the water beneath it.

Static water

An easy way to study static water is to draw a simple display of flowers in a clear glass vase.

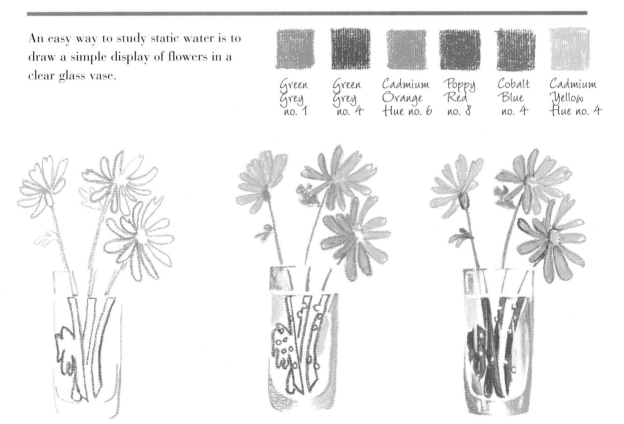

Green Grey no. 1

Green Grey no. 4

Cadmium Orange Hue no. 6

Poppy Red no. 8

Cobalt Blue no. 4

Cadmium Yellow Hue no. 4

1 *Draw the flowers as simple shapes. Note how the stems appear to displace behind the glass and magnify beneath the water's surface.*

2 *Air bubbles on the stalks are a further clue to the presence of water. Look also for the reflected colours of neighbouring objects.*

3 *When you paint the stalks, leave vertical streaks of reflected light to indicate the surface of the glass vase.*

Reflections

The appearance of reflections varies according to subject, weather and the stillness or movement of the water. Paint what you see rather than making assumptions as to how they will look.

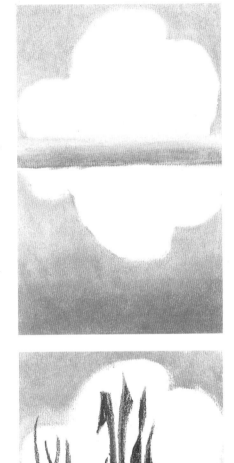

1 *A calm pond produces an exact mirror image. Both cloud and reflection are equal when measured from the horizon (the top of the green band).*

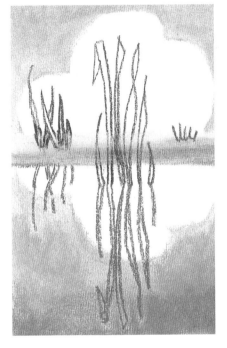

Cobalt Blue no. 2

Cobalt Blue no. 4

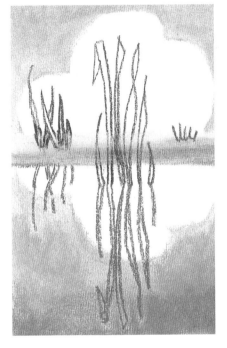
Sap Green no. 1

Sap Green no. 8

Hooker's Green no. 8

2 *Rushes standing in water are reflected in their entirety. Those on the bank are only partially reflected, while those further back are not reflected at all.*

3 *Water movement creates dislocated images. Notice that dark objects reflect lighter and light objects reflect darker. This is known as tonal counterchange.*

EXERCISE Making waves

The continuous movement of the sea is initially daunting, but do not be tempted to use paintings or photographs for reference. Sit on a beach and make reflex drawings, then diagrams in colour. Build your sea picture by bringing them together.

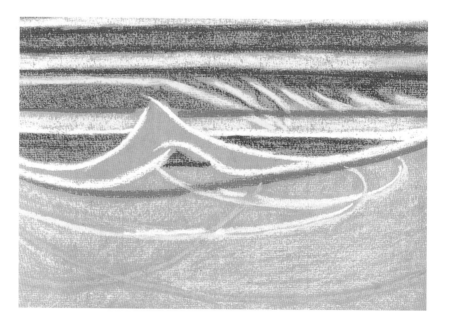

1 Make a set of diagrams from direct observation. Here, blue represents unbroken waves; yellow is rolling waves; turquoise marks the area of surf; cream is the lines of the backwash; orange marks the tidelines; and white is the surf.

2 Infill the horizontal waves with alternating blue and white, working carefully between the yellow stripes of the rolling wave. Lightly infill the sand, leaving the structure lines visible. Emphasize the cream backwash with white lines.

The palette

| Yellow Ochre no. 6 | Yellow Ochre no. 4 | Lemon Yellow no. 2 | Silver White | Lemon Yellow no. 6 | Blue Green no. 1 | Coeruleum no. 8 |

3 *Blend blue and white waves together, then interlock them with a scribbling of turquoise. Drag the curved turquoise line into the backwashed sand. Fix, then drag ochre over the wet sand, leaving gaps for reflections.*

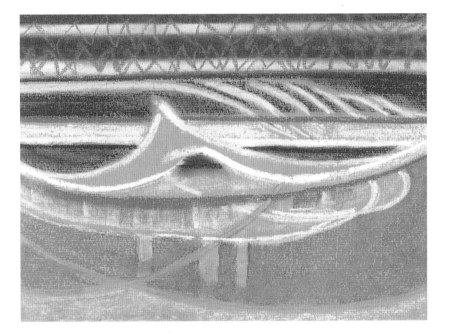

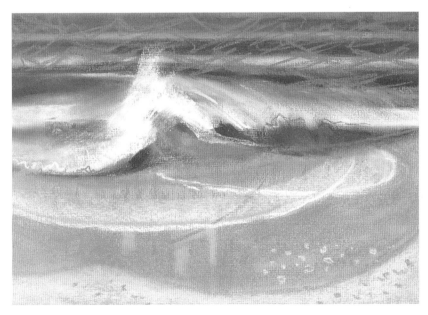

4 *Blend blue, white and yellow waves then retouch the horizontal scribbled texture. Stipple the pebbles, counterchanging orange on cream and cream on ochre. Infill white surf from opposite directions and smudge the point of collision upwards with a finger.*

DEMONSTRATION A SHORELINE

AT A GLANCE...

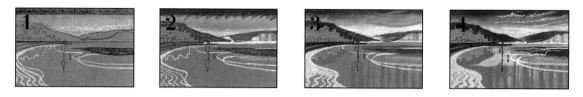

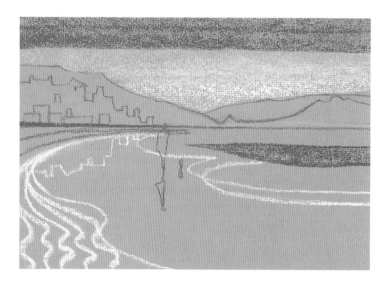

1 This low-level view avoids the complications of eye level that come with clifftop scenes. First draw the eye level and then the figure and its reflection, the hills, buildings, curves of sand, tideline, sea and the town's reflection, in that order. Lightly infill the wave and the sky.

2 Infill the promenade and the hills. Add white for the valley, the furthest edge of the sea and the building behind. Pull vertical stripes of white and pale yellow over the cliff face and drag yellow across the wave.

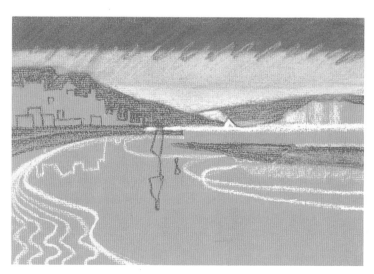

The palette

Coeruleum
no. 6

Lemon
Yellow
no. 2

Raw
Sienna
no. 6

Coeruleum
no. 1

Lemon
Yellow
no. 6

Cadmium
Yellow
no. 4

Silver
White

French
Ultramarine
no. 3

Cadmium
Orange Hue
no. 4

3 *Blend the sky then lift curved stripes from it. Infill the dry sand, leaving ridge patterns. Use ochre for vertical stripes of wet sand and to reflect the the hill above the town. Blend the wave.*

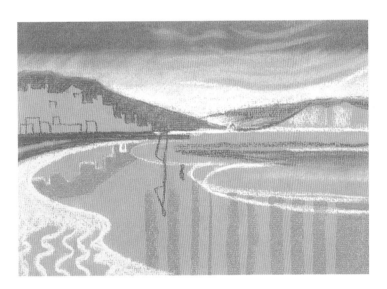

4 *Highlight the clouds and surf with white. Blend the hills and add yellow, orange and pale blue to the wet sand. Add warm blue to the left edge of the promenade, the hill and the reflection of the figure.*

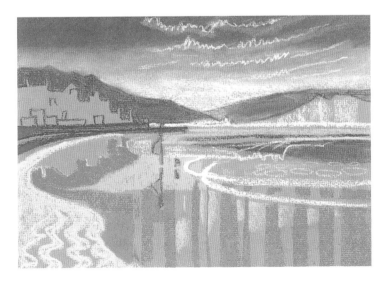

5 *Finished picture:* 25 x 34cm (9¾ x13½in).
*Add minimal patches of colour to the town,
dog and figure. Drag pale yellow vertically over
the furthest area of wet sand. Shadow the
ridges of wet sand with orange. Blend the white
in the sky and sea and put in the reflections of
the buildings.*

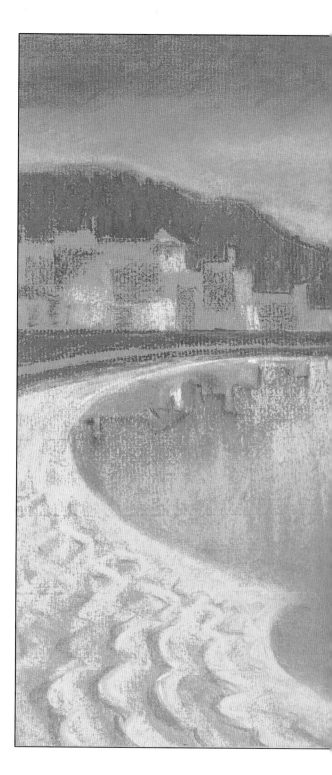

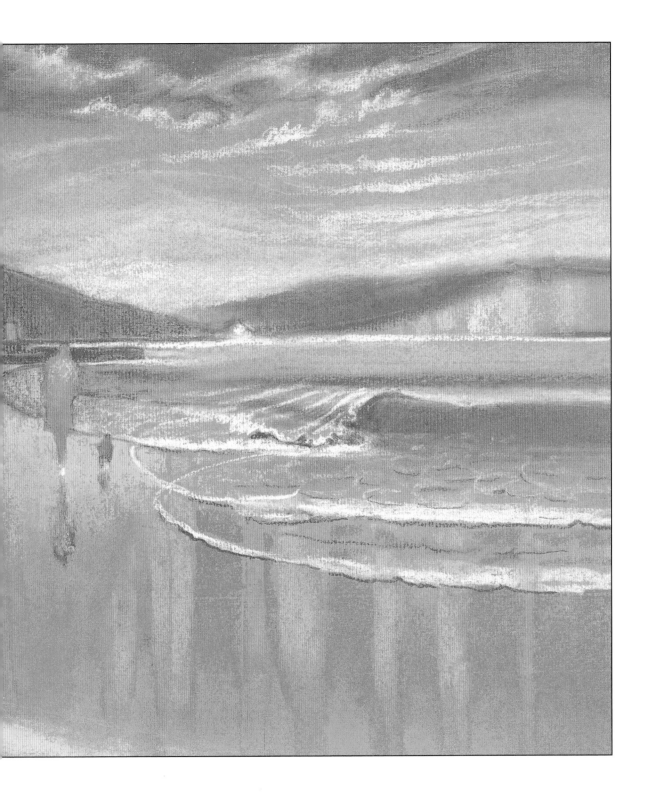

Pebbles

When we first pick up pebbles on a beach we are attracted by their shiny wet surface and limpid colours. These soften when they are dry, and it is then their tactile qualities that provide interest.

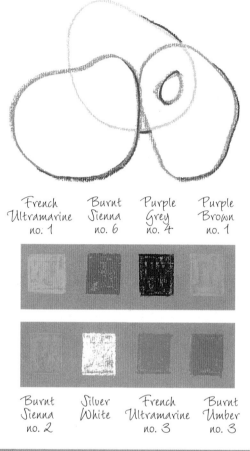

French Ultramarine no. 1 Burnt Sienna no. 6 Purple Grey no. 4 Purple Brown no. 1

Burnt Sienna no. 2 Silver White French Ultramarine no. 3 Burnt Umber no. 3

1 Handle some pebbles and make reflex drawings. Start with blue and then change to brown; a warm colour overlapping cool suggests recession within a group.

2 Erase unwanted lines and infill colour from the edges. Drag light colour across upper surfaces and dark on undersides. Counterchange blue on brown, brown on blue.

3 Blend colours together, adjusting the contrasts of light against dark. Add a cast shadow but allow a gap of light to pass between the pebbles.

1 *Take your sketchbook to a beach. Observe the way the pebbles progress from large to small and from warm to cool as they recede.*

2 *Darken the spaces between the pebbles and infill the exposed parts of the pebbles, maintaining the warm to cool progression. Aim for uniformity relieved by a focus in the middle ground, which here is the hole in one pebble.*

3 *Add lighter colour to the upper sides of the pebbles and strengthen the colour of the shaded areas. Accentuate the hole in the focal pebble by highlighting it to one side and putting a touch of brighter colour within it.*

Limpets

Shells add interest to water subjects or a still life and are attractive objects on which to practise pastel painting. Find some shells and explore their shapes and growth patterns. Limpets have contour lines like hills on a relief map. but the periwinkle is a free-flowing spiral.

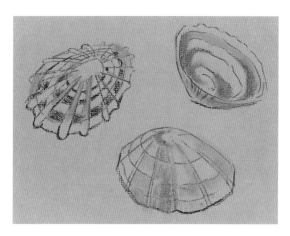

1 *Draw the contours from above, underneath and from the side with charcoal, carefully following the form of the shell.*

2 *Lightly draw visible contours and radiating lines in purple-grey. Fill the nearer ridges and one inner contour with the darker raw sienna. Blend some of the purple-grey on each shell.*

3 *Add the lighter raw sienna. Place purple-grey spots on the front shell and infill the spaces on the grey shell with coeruleum, then add the white highlights.*

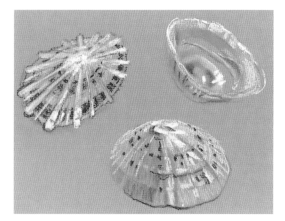

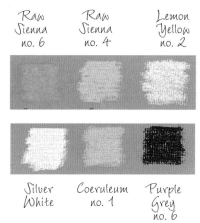

Raw Sienna no. 6

Raw Sienna no. 4

Lemon Yellow no. 2

Silver White

Coeruleum no. 1

Purple Grey no. 6

Periwinkles

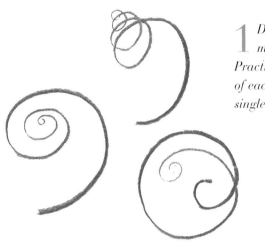

1 Draw each spiral as a single
movement with charcoal.
Practise drawing from the centre
of each shell outwards with a
single stroke.

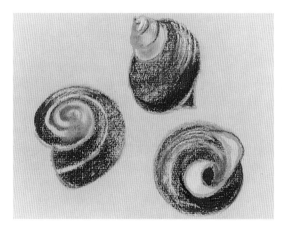

2 Lightly draw the outlines in
orange, then use purple-
grey within each spiral. Leave
paper untouched for the stripes
and add white lines to show the
surface pattern.

3 Add the blue and gently blend.
Complete the 'ear' of the shell with
both the purples and accented touches of
orange. Add the white highlights.

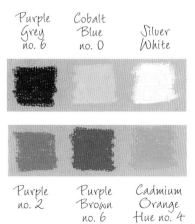

Purple Cobalt
Grey Blue Silver
no. 6 no. 0 White

Purple Purple Cadmium
no. 2 Brown Orange
 no. 6 Hue no. 4

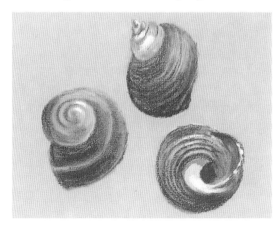

Seaweeds

There are many living organisms to be found along the seashore that are ideal for painting on a smaller scale. Freeform subjects such as seaweeds and sea anemones are satisfying to draw.

1 Practise using a continuous line for each drawing. You will find it easiest to work from individual specimens.

2 Look for reds and yellows in brown seaweed. Infill the colours by blending them inwards from the drawn outlines, as shown here on the green seaweed.

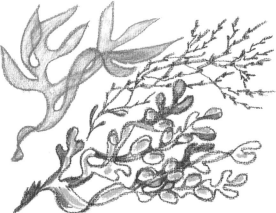

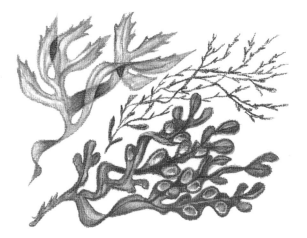

3 Translucence is conveyed in the green seaweed by the darkening of twists and overlaps. Leave white highlights to identify the blisters on brown seaweed.

Sea anenomes

1 *Sit beside a rockpool with your sketchbook and draw the brown or greenish blobs that open up into the 'flowers' of sea anemones.*

2 *Choose a maximum of three colours that identify each subject. Add tonal contrasts by blending and infilling outlines.*

Hooker's Green no. 1 Olive Green no. 8 Poppy Red no. 8

Cadmium Orange Hue no. 4 Purple Brown no. 6 Sap Green no. 8

3 *Either finish at home from the sketches and notes or complete the painting on site. Lift or add highlights for shiny surfaces and add colour detail.*

DEMONSTRATION ROCKPOOL

AT A GLANCE...

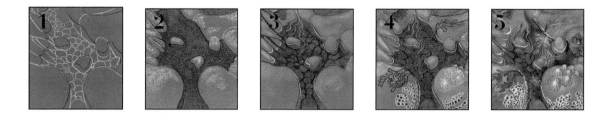

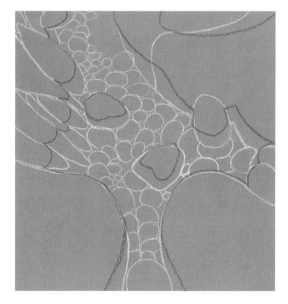

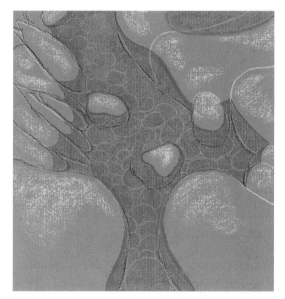

1 Rockpools combine aspects of all the seashore studies you have made. Looked at from above, they present a way of seeing that is different from our usual horizontal or vertical way of seeing things. Although recession is irrelevant, overlap pebbles from the base, establishing the direction for viewing.

2 Submerge the pebbles by lightly dragging and blending blue within the designated area of water. Drag pale yellow highlights over the projecting pebbles and rocks.

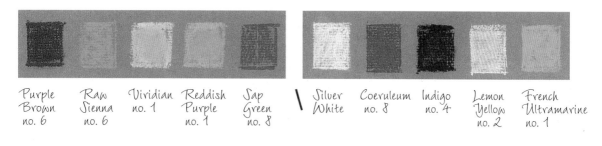

| Purple Brown no. 6 | Raw Sienna no. 6 | Viridian no. 1 | Reddish Purple no. 1 | Sap Green no. 8 | Silver White | Coeruleum no. 8 | Indigo no. 4 | Lemon Yellow no. 2 | French Ultramarine no. 1 |

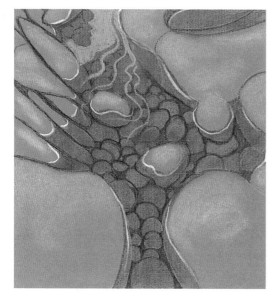

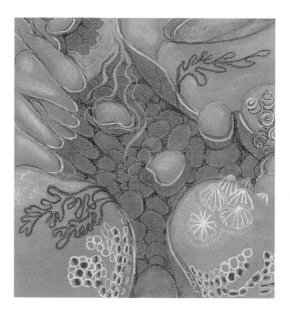

3 Blend yellow into grey. Outline the pebbles and blend into the spaces. Add a patch of ripples and reflected sky. Next, add a white outline at the water's edge.

4 Seaweeds and shells add texture and give form to the rocks. From above shells are seen full circle but they graduate to profiles on the down curve of the rocks.

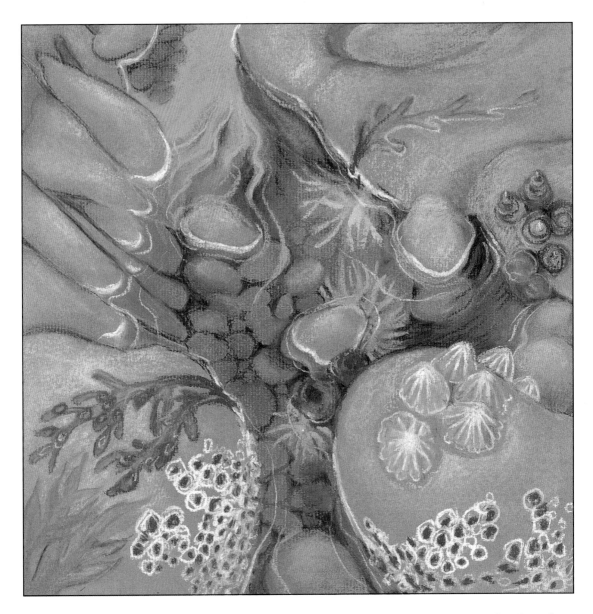

5 **Finished picture:** *23 x 23cm (9 x 9in).
Sea anemones in flower will be below the
water. Partially blend them with blue and
superimpose ripples. Closed anemones may sit*
*above the water level. Complete details such as
the reflections and the infilling of the seaweed
and shells in the way you learnt from the indi-
vidual studies on the previous pages.*